P9-DGE-948

CONTENTS

▼

▼

THE MOST COMMON RESPONSE FROM THE PHOTOGRAPHERS WHO CONTRIBUTED TO THIS BOOK, WHEN THE CONCEPT WAS EXPLAINED TO THEM, WAS "I'D BUY THAT". THE AIM IS SIMPLE: TO CREATE A LIBRARY OF BOOKS, ILLUSTRATED WITH FIRST-CLASS PHOTOGRAPHY FROM ALL AROUND THE WORLD, WHICH SHOW EXACTLY HOW EACH INDIVIDUAL PHOTOGRAPH IN EACH BOOK WAS LIT.

Who will find it useful? Professional photographers, obviously, who are either working in a given field or want to move into a new field. Students, too, who will find that it gives them access to a much greater range of ideas and inspiration than even the best college can hope to present. Art directors and others in the visual arts will find it a useful reference book, both for ideas and as a means of explaining to photographers exactly what they want done. It will also help them to understand what the photographers are saying to them. Finally, of course, "pro/am" photographers who are on the cusp between amateur photography and earning money with their cameras will find it invaluable: it shows both the standards that are required, and the means of achieving them.

The lighting set-ups in each book vary widely, and embrace many different types of light source: electronic flash, tungsten, HMIs, and light brushes, sometimes mixed with daylight and flames and all kinds of other things. Some are very complex, while others are very simple. This variety is important, both as a source of ideas and inspiration and because each book as a whole has no axe to grind: there is no editorial bias towards one kind of lighting or another, because the pictures were chosen on the basis of impact and occasionally on the basis of technical difficulty. Certain subjects are, after all, notoriously difficult to light and can present a challenge even to experienced photographers. Only after the picture selection has been made was there any attempt to understand the lighting set-up.

While the books were being put together, it was however interesting to

see how there was often a broad consensus of opinion on equipment and techniques within a particular discipline. In food photography for example, one might correctly have predicted that most

photographers would use cool-running flash rather than hot tungsten, which melts ice-cream and dries out moist food; but the remarkable prevalence of slight back lighting might not have been so immediately obvious to anyone not

experienced in that field. In glamour, there was much more use of tungsten – perhaps to keep the model warm? – but a surprising number of photographers shot daylight film under tungsten lighting for a seriously warm effect. After going through each book, one can very nearly devise a "universal lighting set-up" which will work for the majority of pictures in a particular speciality, and which needs only to be tinkered with to suit individual requirements. One will also see that there are many other ways of doing things.

The structure of the books is straightforward. After this initial introduction, which is common to all the books in the series, there is a brief guide and glossary of lighting terms. Then, there is a specific introduction to the individual area or areas of photography which are covered by the book. Sub-divisions of each discipline are arranged in chapters, inevitably with a degree of overlap, and each chapter has its own introduction. Finally, at the end of the book, there is a directory of those photographers who have contributed work.

If you would like your work to be considered for inclusion in future books, please write to Quarto Publishing, 6 Blundell Street, London, N7 9BH, England, and request an Information Pack. DO NOT SEND PICTURES, either with the initial inquiry or with any subsequent correspondence, unless requested; unsolicited pictures may not always be returned. When a book is planned which corresponds with your particular area of expertise, we will contact you. Until then, we hope that you enjoy this book, that you find it useful, and that it helps you in your work.

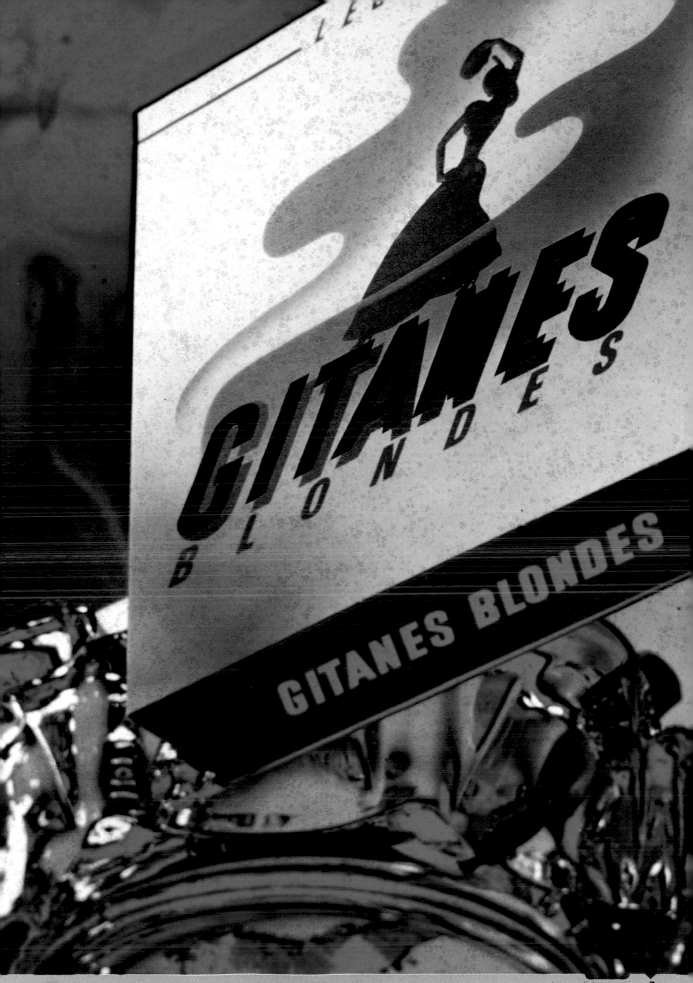

HOW TO USE THIS BOOK

▼

THE LIGHTING DRAWINGS IN THIS BOOK WERE PREPARED FROM SKETCHES SUPPLIED BY THE PHOTOGRAPHERS THEMSELVES. NEEDLESS TO SAY, THESE VARIED SOMEWHAT IN QUALITY AND IN THE CARE WITH WHICH THEY WERE PUT TOGETHER. THEY HAVE HOWEVER BEEN CHECKED AGAINST THE PICTURES BY AN EXPERIENCED INDEPENDENT PHOTOGRAPHER, AND WHERE THERE WERE DISCREPANCIES, WE HOPE THAT THEY HAVE ALL BEEN CLARIFIED.

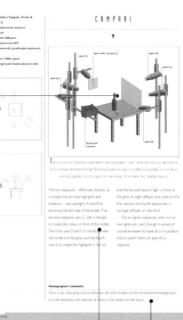

Technical information on the equipment used for each picture

Three-dimensional diagrams show how the lighting was set up

Plan and side views clarify the lighting set up

Full page colour picture of the final image

Commentary explains how the lighting set up was approached by the photographer

Photographer's personal comment on his picture

The drawings are not necessarily to scale, but that does not matter. After all, no photographer works strictly according to rules and preconceptions: there is always room to move this light a little to the left or right, to move that light closer or further away, and so forth. Likewise, the precise power of the individual lighting heads, or more importantly the lighting ratios are not always given; but again, this is something which can be "fine tuned" by the photographer if he or she wishes to reproduce the lighting set-ups in here. Besides, flash heads vary widely in efficiency, and therefore in light output

for a given rated power, and reflectors also vary widely in efficiency. In any case, people cannot always remember the finer details of what they did: lights are moved this way and that, or their power turned up or down, in accordance with the needs of the shot, and no records are kept.

We are however confident that there is more than enough information given about every single shot to merit its inclusion in the book: as well as just lighting techniques, there are also all kinds of hints and tips about commercial realities, photographic practicalities, and

the way of the world in general.

The book can therefore be used in a number of ways. The most basic, and perhaps the most useful for the beginner, is to study all the technical information concerning a picture which he or she particularly admires, together with the lighting diagrams, and to try to duplicate that shot as far as possible with the equipment available. We have deliberately omitted information about which makes of camera and lens were used, because it really does not matter very much whether you use a Linhof or an Arca or a Sinar; the important thing is

Pro·Lighting

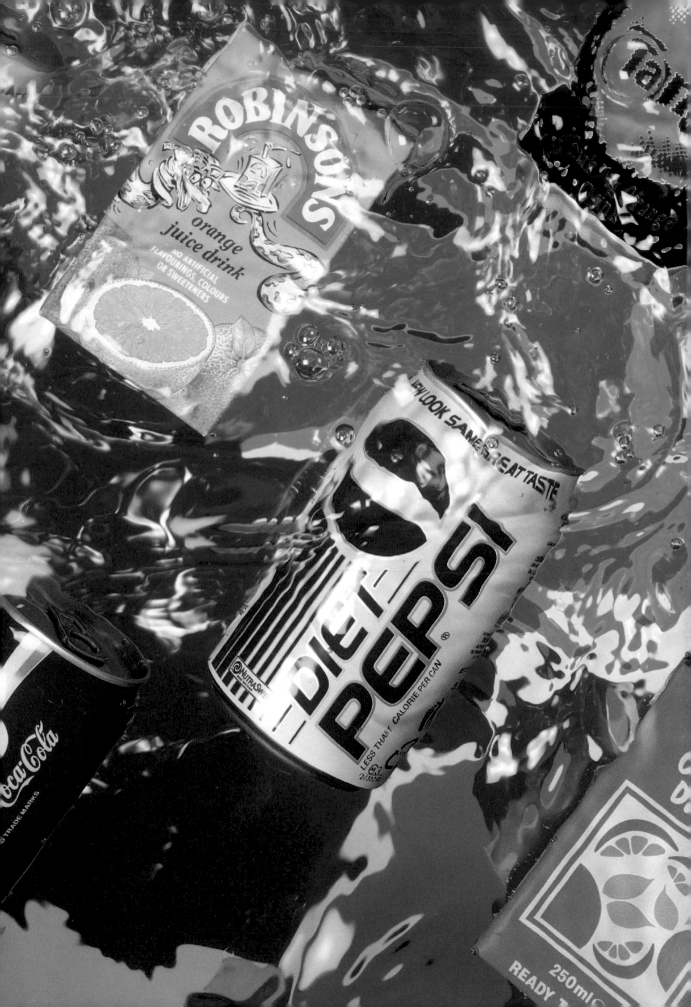

Pro·Lighting

ROGER HICKS and FRANCES SCHULTZ

PRODUCT
SHOTS

ROTOVISION

A Quarto Book

Published and distributed by ROTOVISION SA
7 rue du Bugnon
1299 Crans
Switzerland

RotoVision Sales and Production Office
Sheridan House
112/116A Western Road
Hove BN3 1DD England
Tel +44 1273 727268
Fax +44 1273 727269

Distributed to the trade in the United States:
Watson-Guptill Publications
1515 Broadway
New York, NY 10036

2nd Reprint 1997
ISBN 2-88046-228-2

This book was designed and produced by
Quarto Publishing plc
6 Blundell Street
London N7 9BH

Creative Director: Richard Dewing
Designer: Mark Roberts
Editor: Sue Thraves
Project Editor: Anna Briffa
Picture Researchers: Roger Hicks and Frances Schultz

Typeset in Great Britain by
Central Southern Typesetters, Eastbourne
Printed in Singapore by Teck Wah Paper Products Ltd.
Production and Separation in Singapore by ProVision Pte. Ltd.
Tel: +65 334 7720
Fax: +65 334 7721

the format. The same would be true of a Hasselblad or a Mamiya. The same is of course true of the focal length: using a 127mm lens on a 6x7 cm camera is after all much the same as using 110mm or 120mm on 6x6 cm.

A more advanced use for the book is as a problem solver for difficulties you have already encountered: a particular technique of back lighting, say, or of creating a feeling of light and space. And, of course, it can always be used simply as a source of inspiration: "I wonder what would happen if I took *this* technique and applied it to *this* subject . . ."

The information for each picture follows the same plan, though some individual headings may be omitted if they were irrelevant or unavailable. The photographer is credited first, then the client, together with the use for which the picture was taken. Next come the other members of the team who worked on the picture: stylists, models, art directors, or whoever. Camera and lens come next, followed by exposure. Where the lighting is electronic flash, only the aperture is given, as illumination is of course independent of shutter speed. Next, the lighting equipment is briefly summarized – whether tungsten or flash, and what sort of heads – and then comes film. With film, we have named brands and types, because different films have very different ways of rendering colours and tonal values. Finally there is a brief note on props and backgrounds. Often, this last entry will be obvious from the picture, but in other cases you may be surprised at what has been pressed into service, and how different it looks from its normal role.

However the most important part of the book is the pictures themselves. By studying these, and referring to the lighting diagrams and the text as necessary, you can work out how they were done; and showing how things are done is the brief to which the *Pro Lighting* series was created.

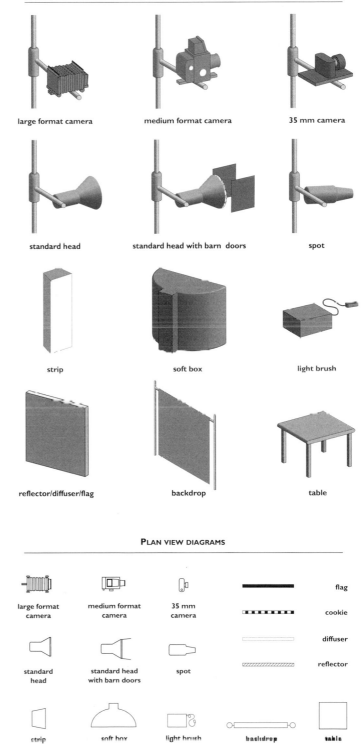

DIAGRAM KEY

The following is a key to the symbols used in the three-dimensional and plan view diagrams. All commonly used elements such as standard heads, reflectors etc., are listed. Any special or unusual elements involved will be shown on the relevant diagrams themselves.

THREE-DIMENSIONAL DIAGRAMS

large format camera medium format camera 35 mm camera

standard head standard head with barn doors spot

strip soft box light brush

reflector/diffuser/flag backdrop table

PLAN VIEW DIAGRAMS

large format camera medium format camera 35 mm camera flag

standard head standard head with barn doors spot cookie

 diffuser

 reflector

strip soft box light brush backdrop table

GLOSSARY OF LIGHTING TERMS

▼

Lighting, like any other craft, has its own jargon and slang. Unfortunately, the different terms are not very well standardized, and often the same thing may be described in two or more ways or the same word may be used to mean two or more different things. For example, a sheet of black card, wood, metal or other material which is used to control reflections or shadows may be called a flag, a French flag, a donkey or a gobo — though some people would reserve the term "gobo" for a flag with holes in it, which is also known as a cookie. In this book, we have tried to standardize terms as far as possible. For clarity, a glossary is given below, and the preferred terms used in this book are asterisked.

Acetate

see Gel

Acrylic sheeting

Hard, shiny plastic sheeting, usually methyl methacrylate, used as a diffuser ("opal") or in a range of colours as a background.

***Barn doors**

Adjustable flaps affixed to a lighting head which allow the light to be shaded from a particular part of the subject.

Barn doors

Boom

Extension arm allowing a light to be cantilevered out over a subject.

***Bounce**

A passive reflector, typically white but also, for example, silver or gold, from which light is bounced back onto the subject. Also used in the compound term "Black Bounce", meaning a flag used to absorb light rather than to cast a shadow.

Continuous lighting

What its name suggests: light which shines continuously instead of being a brief flash.

Contrast

see Lighting ratio

Cookie

see Gobo

***Diffuser**

Translucent material used to diffuse light. Includes tracing paper, scrim, umbrellas, translucent plastics such as Perspex and Plexiglas, and more.

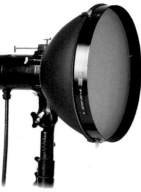

Electronic flash: standard head with parallel snoot (Strobex)

Donkey

see Gobo

Effects light

Neither key nor fill; a small light, usually a spot, used to light a particular part of the subject. A hair light on a model is an example of an effects (or "FX") light.

***Fill**

Extra lights, either from a separate head or from a reflector, which "fills" the shadows and lowers the lighting ratio.

Fish fryer

A small Soft Box.

***Flag**

A rigid sheet of metal, board, foam-core or other material which is used to absorb light or to create a shadow. Many flags are painted black on one side and white (or brushed silver) on the other, so that they can be used either as flags or as reflectors.

***Flat**

A large Bounce, often made of a thick sheet of expanded polystyrene or foam-core (for lightness).

Foil

see Gel

French flag

see Flag

Frost

see Diffuser

***Gel**

Transparent or sometimes translucent coloured material used to modify the colour of a light. It is an abbreviation of "gelatine (filter)", though most modern "gels" for lighting use are actually of acetate.

***Gobo**

As used in this book, synonymous with "cookie": a flag with cut-outs in it, to cast interestingly-shaped shadows. Also used in projection spots.

"Cookies" or "gobos" for projection spotlight (Photon Beard)

***Head**

Light source, whether continuous or flash. A "standard head" is fitted with a plain reflector.

***HMI**

Rapidly-pulsed and

effectively continuous light source approximating to daylight and running far cooler than tungsten. Relatively new at the time of writing, and still very expensive.

***Honeycomb**

Grid of open-ended hexagonal cells, closely resembling a honeycomb. Increases directionality of

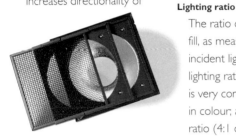

Honeycomb (Hensel)

light from any head.

Incandescent lighting

see Tungsten

Inky dinky

Small tungsten spot.

***Key or key light**

The dominant or principal light, the light which casts the shadows.

Kill Spill

Large flat used to block spill.

***Light brush**

Light source "piped" through fibre-optic lead. Can be used to add highlights, delete shadows and modify lighting, literally by "painting with light".

Electronic Flash: light brush "hose" (Hensel)

Lighting ratio

The ratio of the key to the fill, as measured with an incident light meter. A high lighting ratio (8:1 or above) is very contrasty, especially in colour; a low lighting ratio (4:1 or less) is flatter or softer. A 1:1 lighting ratio is completely even, all over the subject.

***Mirror**

Exactly what its name suggests. The only reason for mentioning it here is that reflectors are rarely mirrors, because mirrors create "hot spots" while reflectors diffuse light. Mirrors (especially small shaving mirrors) are however widely used, almost in the same way as effects lights.

Northlight or North Light

see Soft Box

Perspex

Brand name for acrylic sheeting.

Plexiglas

Brand name for acrylic sheeting.

***Projection spot**

Flash or tungsten head with projection optics for casting a clear image of a

gobo or cookie. Used to create textured lighting effects and shadows.

Electronic Flash: projection spotlight (Strobex)

Tungsten Projection spotlight (Photon Beard)

***Reflector**

Either a dish-shaped surround to a light, or a bounce.

***Scrim**

Heat-resistant fabric diffuser, used to soften lighting.

***Snoot**

Conical restrictor, fitting over a lighting head.

The light can only escape from the small hole in the

Tungsten spot with conical snoot (Photon Beard)

Electronic Flash: standard head with parallel snoot (Strobex)

end, and is therefore very directional.

***Soft box**

Large, diffuse light source made by shining a light through one or two layers of diffuser. Soft boxes come in all kinds of

Electronic Flash: light brush "pencil" (Hensel)

Tungsten spot with safety mesh (behind) and wire half diffuser scrim (Photon Beard)

Electronic flash: standard head with large reflector and diffuser (Strobex)

shapes and sizes, from about 30x30cm to 120x180cm and larger. Some soft boxes are rigid; others are made of fabric stiffened with poles resembling fibreglass fishing rods. Also known as a northlight or a windowlight, though these can also be created by shining standard heads through large (120x180cm or larger) diffusers.

***Spill**

Light from any source which ends up other than on the subject at which it is pointed. Spill may be used to provide fill, or to light backgrounds, or it may be controlled with flags, barn doors, gobos etc.

***Spot**

Directional light source. Normally refers to a light using a focusing system with reflectors or lenses or both, a "focusing spot", but also loosely used as a reflector head rendered more directional with a honeycomb.

***Strip or strip light**

Lighting head, usually flash, which is much longer than it is wide.

Electronic flash: strip light with removable barn doors (Strobex)

Strobe

Electronic flash. Strictly, a "strobe" is a stroboscope or rapidly repeating light source, though it is also the name of a leading manufacturer.

Tungsten spot with removable Fresnel lens. The knob at the bottom varies the width of the beam (Photon Beard)

Strobex, formerly Strobe Equipment.

Swimming pool

A very large Soft Box.

***Tungsten**

Incandescent lighting. Photographic tungsten

Electronic flash: standard head with standard reflector (Strobex)

lighting runs at 3200°K or 3400°K, as compared with domestic lamps which run at 2400°K to 2800°K or thereabouts.

***Umbrella**

Exactly what its name suggests; used for modifying light.

Umbrellas may be used as reflectors (light shining into the umbrella) or diffusers (light shining through the umbrella). The cheapest way of creating a large, soft light source.

Windowlight

Apart from the obvious meaning of light through a window, or of light shone through a diffuser to look as if it is coming through a window, this is another name for a soft box.

Tungsten spot with shoot-through umbrella (Photon Beard)

PRODUCT SHOTS

▼

At its simplest, a product or pack shot is exactly what its name suggests: a plain, straightforward picture of a product or pack to be used on its own or to be stripped into a more complex image, whether photographically, mechanically, or electronically. At its most complex, it is a picture of a product (in or out of its package) which vies with the finest still lifes ever painted or photographed; the only difference between a product shot and a still life at this point is that the product shot is a picture of something that someone is trying to sell. Usually, though not invariably, the product name will be prominent in the picture; and this is the criterion which we have adopted in this book.

Paradoxically, though, the simplest product shots can be the most demanding. To begin with, trying to get a perfect pack is usually a major problem. Printing blemishes, scratches, dented corners; none of these things matter when we reach onto the shelf to buy something, because we know that we are eventually going to throw the pack away. As a rule, we only worry about minor blemishes when we are buying a gift, or something where the packaging is a part of the appeal of the item in question. Few of us would buy a scratched box of expensive perfume, for example, and booksellers normally sell what they call "hurt" or damaged books at a discount. Even in these areas, though, we are normally prepared to put up with products in considerably worse condition than would be acceptable for photography.

There are several ways around this, including the use of models to replace the actual product; but with an ever-increasing pressure for "truth in advertising", and the danger that the model itself may in some way be flawed or damaged, it is quite common to use the product or pack itself. This often means that someone, typically the photographer's assistant, goes through dozens or even hundreds of packs, picking out the few that are acceptable for photography. It is not unknown, if the product is to be shown from several angles, to select one for head-on shots, another for three-quarter, another for top shots, and so forth. It is quite usual

for one good pack to be assembled, with scalpel, glue and tape, from several with defects.

A variant of this difficulty is when the product will not stand the degree of enlargement which it will receive in the picture. The classic example of this is a pill. Blow it up to the kind of size where you can read the lettering on it, and the coating looks like the surface of the moon. Model-making, or re-thinking the shot completely, is the only answer in these cases.

The next problem is that many packs and products are dull in the extreme; they are designed to stand in rows on a supermarket shelf, rather than to be examined in isolation as they are in a product shot. The most usual way around this problem is skillful lighting.

This is not necessarily the same thing as lighting it particularly originally. One of the near-clichés of product shots is the graded background, which can be achieved either by lighting (which is beginning to look increasingly like the hard way to do it) or by using a ready-graded background. These are now available in a variety of colours and intensities, shading from light to dark, and are a quick and relatively easy fix to an old and often intractable problem.

For another cliché, you may wince when confronted with a product which has obviously been lit through powerfully coloured filters, but all too often, this may be the only way to make a plain shape at least eye-catching, if not actually interesting.

When it comes to more complex pictures, which use props as well as the pack or product, it can be difficult to draw a line between product shots and other types of photography. It is, after all, hard to draw a clear philosophical distinction between, say, a roll-on deodorant on an expensive dressing table, and an elegantly-manicured hand holding that same deodorant, presumably with the intention of using it; but as soon as a model comes into the picture, in common parlance it is no longer regarded as a product shot. Logically though, a model can be regarded as an accessory to a product, so a product shot with a hand in it is by no means an impossibility.

There is also a question of size. Essentially, a car shot is no more than a very large product shot; but because photographing automobiles has its own difficulties and conventions and requirements, car photography is viewed as a completely different branch of photography. Many photographers would be unhappy to define anything as a "product shot" where they could not pick up the subject without assistance, whether it is a packet of pills or a domestic appliance. Even so, the same applies to big product shots as to product shots with models in them; in the long run, they are still product shots.

THE PURPOSE OF PRODUCT SHOTS

The purpose of product shots is simple. They are to make people buy the product. If they do not buy it, then at

least they will retain a mental image of the product, and they may buy it when they have a need or desire for something similar. You may not be in the market for a gold cigarette lighter, for example, and even if you are, you are unlikely to buy them often; but Cartier's advertising and PR ensure that their brand recognition is astonishingly high.

A much more interesting question is how a product shot helps to sell the product. No doubt, there are a few cases where sheer elegance of design, or even novelty, causes people to buy; but for the most part, the product shot must in some way epitomize the emotional appeal of the product. A headache cure must be clean, efficient, clinical. Bath gel must again be clean, but in a much less clinical sort of way; water splashed over the pack will make it look dewy-fresh and ready to use. Chocolates must look rich and inviting; a box of eggs must look farm-fresh and natural. Only rarely will a straight shot of a product do this, which is why lighting and (in many cases) the choice of props can be so important.

At this point, one is sliding into the "lifestyle" type of shot. Rather than just showing a few shotgun shells on a sheet of background paper, one puts them on weathered wood to suggest the country look; and perhaps adds a brace of grouse, to convey the message that if you buy this particular sort of ammunition, you will regularly hit everything you aim at. Then there might be part of a gun in shot. People are often astonished at the amount of trouble and expense which goes into building an apparently trivial campaign, but there is no doubt that if you do it properly, advertising gets results.

Finally, there are times when the sole function of a product shot is to break up what would otherwise be a featureless text-only advertisement, or (at best) to confirm its appearance. If, for example, you were advertising table-top photocopiers, you might want to have your product in the advertisement. Why? Partly for visual variety; partly because

advertisers have a weakness for putting pictures of their products into their advertising, no matter how dull those products may be; and partly to confirm that it is genuinely of table-top size. This is the sort of shot where the above-mentioned multi-coloured gels can render a dull subject less dull.

DREAMS AND REALITY

Perhaps more than in any other branch of photography, product shots illustrate the gap between the ideal world and the real world. In glamour photography, the fantasy or idealization is implicit: no-one expects a world populated exclusively with beautiful women, and no-one expects even beautiful women to be beautiful all the time. In food photography, although there are still plenty of "picture-perfect" shots, the realistic style associated with *Marie-Claire* magazine and others is growing in popularity. But this does not happen with product shots. Instead, the pictures portray perfection. We do not compare the product shot and the reality, though, so for the most part we fail to notice the gap between perfection and reality.

Strangely enough, realistic and real-world variations of the product shot are a staple of fine art. An empty, dented tin of Fosters; the bent, levered-off top from a Coca-Cola bottle; a cigarette burnt almost to the filter, with the ash improbably long; these and many similar subjects have been rendered superbly by a number of artists. Perhaps there is yet room for the crumpled pack of cigarettes, or the empty oil-bottle in the bin; or perhaps such pictures will remain the domain of the painter, especially the airbrush artist who can idealize even the broken and the discarded.

THE PRODUCT SHOT STUDIO

A great number of product shots can be taken in a very small studio; they are, after all, no more than table-top shots, so all you need is a table with a couple of metres all around it where you can set

up the lighting. You need enough room to swing a soft box (to which we shall return in a moment), but otherwise, you do not need a large studio.

For versatility, though, you do need somewhere rather bigger; somewhere, for a start, where you can light a background independently and where you can, if necessary, build a small set or stand an appropriate piece of furniture. Anyone who shoots product shots is likely, therefore, to spend a great deal of time working in just a corner (or in the middle of one wall) of a significantly larger studio. The alternative, which is adopted by many photographers, is to run just a small studio in which they do the majority of their work, then hire a larger studio for pictures which require more room.

You also need a view camera with as many movements as you can get, including rising and cross back, because a great deal of pack photography requires extensive use of movements.

LIGHTING EQUIPMENT FOR PRODUCT SHOTS

One objection to hiring a larger studio when you need it is that top-level product shots can demand a remarkable amount of lighting – and not just lighting, but all the associated reflectors, flags, mirrors-on-stands and so forth. The point is that taking product shots is often a very fiddly and precise sort of affair, where minute adjustments to lights and to the subject are the order of the day. Often, the client would never be able to describe or analyze the difference between two or three versions of a shot, all tested on Polaroid before choosing the final one, but each would be slightly different, and the final one would be subtly the best. It might be something as slight as holding an edge more clearly, whether by back lighting or using a flag or kicking a little more light in from a heavily snooted spot; but the difference would be there, and as soon as it was pointed out, the client would say, "Of course! I see!" Until then, there would just be a general, undifferentiated understanding

that one shot was better than another.

Exactly what sort of lighting you use will depend on your personal preferences, but the majority of product shot photographers will principally use electronic flash. This is not only because it runs cool – lighting small subjects with plenty of tungsten can cook the photographer, even if the product is unharmed – but also because one of the great staples of product shot photography is the big soft box or "idiot light". At least a metre square, and more typically a metre by a metre and a half, the big soft box provides a close approximation to the old north light beloved of our ancestors, and of course "northlight" is another name for this sort of lighting. Yet other names, popularized by Strobe Equipment (now known as Strobex) who were pioneers in the field and who still make some of the most highly-regarded studio flash lights in the world, are "swimming pool" (for the really big lights) and "fish frier" for the smaller ones, down to as little as half a metre on a side.

The one thing which assistants soon learn, however, is that while the idiot light is the answer to many of their prayers, there are also many things which it cannot do. The most important of these is to create sparkle in jewellery, which for this reason remains one of the great preserves of tungsten lighting. Using electronic flash to create sunlit effects also requires some skill; the easiest (and most expensive) approach is to use a projection spotlight.

It is also quite feasible to mix electronic lighting and tungsten. Although it is normal to filter the tungsten to match the flash, it may also be possible in some cases to use the warm light of the tungsten in its own right. The big advantage of tungsten lies in the relative affordability of focusing spots, which by a happy coincidence create exactly the opposite sort of image that you get from a soft box, though a "trough" – a grid of anything from a dozen to two dozen tungsten bulbs – runs very hot indeed

(a dozen 500 watt bulbs churn out more heat than three two-kilowatt electric fires) and replacement bulbs cost a fortune.

LOGISTICS, PROPS AND BACKGROUNDS

Because the term "product shots" covers such an enormous range, there are very few general guidelines. Picking perfect packs is one, of course, and it is always as well to have some more in reserve in case of accidents. Likewise, backgrounds can be almost anything, though the various proprietary backgrounds such as graduals and false-perspective grids can come into their own. For many products, a transilluminated background is extremely useful, and an "infinity table" of curved opal Perspex or Lucite is generally the easiest way to achieve this. Another way to do it, used by many photographers specializing in small subjects, is to build a cube of opal Perspex or Lucite with one side open; the "scoop" or "sweep" is then made up using Kodatrace or a similar acetate-base tracing paper. One edge is taped to the upper back of the box, and the other is taped to the front, so a smooth, cornerless, and replaceable surface is created. With either the infinity table or this sort of box, you can illuminate subjects so that they appear to be hanging in mid-air against a white background. The opposite effect, of a subject suspended in black space, is most easily achieved with black velvet or a proprietary black flocked background. If there is any danger of the texture of the velvet showing, then using a film such as Velvia and underexposing slightly will ensure that it blocks up to a solid, featureless black. Flock blocks up even more readily, but also mars more easily.

Perhaps the most useful advice to the product shot photographer is to maintain the largest possible "bits box". This is full of things which will come in handy: scalpels (with spare, sharp blades), tapes and adhesives of all kinds, pliers of various shapes and descriptions, soft wire, bulldog clips, bits of felt to prevent one

thing scratching another, dulling spray, self-adhesive Velcro or similar hook-and-loop material, all kinds of cleaning materials, various types of modelling clays and putties, string, worm-drive clips (Jubilee clips), elastic bands... A fishing tackle box filled with this sort of thing will be invaluable, and until you actually need something, you will never know exactly how it will come in handy.

THE TEAM

Some successful product shot photographers do not even have full-time assistants, because they can do everything themselves; indeed, because there would be little need to have anyone to help them. On the other hand, it is extremely handy to be able to ask someone else to do all the things that you want to have done, such as finding a beach-ball and beach towels in January, or collecting flints from the beach, or returning props. Once you are accustomed to working with someone, it is often easier to ask them to move a light while you watch what happens on the ground glass, rather than having to come out from behind the camera to move it yourself, and then trying to remember exactly how it looked before.

TAKING PRODUCT SHOTS

The one thing which you have to allow yourself with product shots is plenty of time, because everything takes longer than it should. It puts one in mind of the old saying: the first half of any job takes ninety per cent of the time, and so does the second half. You need time to clean the pack or product; time to set it up; time to light it; time to take Polaroids; time to re-adjust the lighting... Because simple product shots are one of the things which assistants are often given to do, there is a temptation to discount them as being something that "real" photographers don't do; they leave them to their assistants instead. As the pictures in this book will show, it ain't so; there are some product shot photographers who are as "real" as you can get.

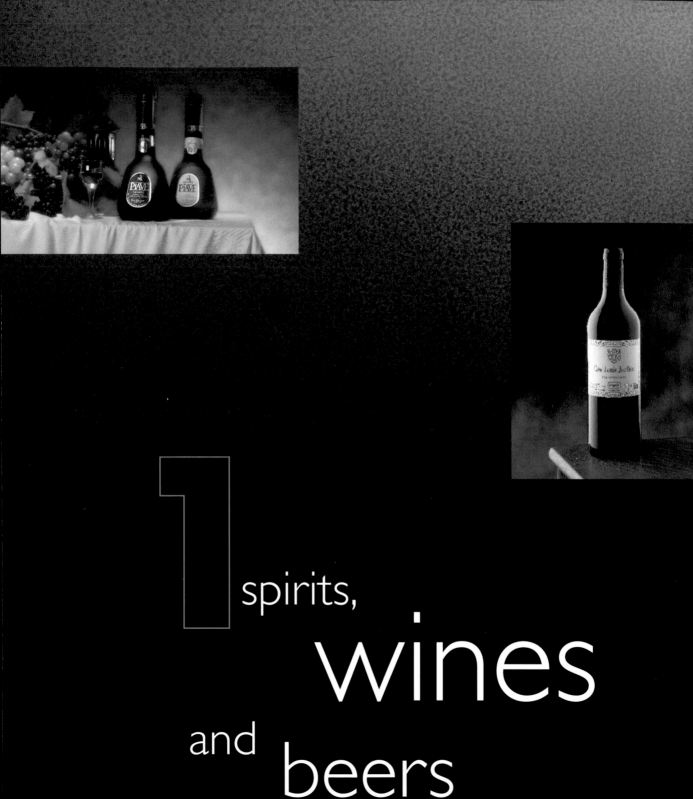

1 spirits,
wines
and beers

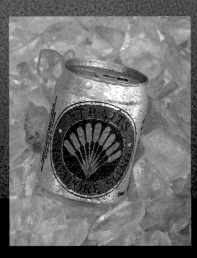

▶ Alcohol and advertising have a natural affinity for one another. The world could survive perfectly well without either; but it would be a very different place. Regardless of one's opinions of advertisements, and some of them are minor works of art in their own right, the revenue which they bring in to magazines and newspapers is effectively what makes publication feasible. The actual cost of printing many magazines is greater than the revenue realized from sales of copies, but the advertising makes up the shortfall and creates the profit as well.

The shots can be of two kinds. They may literally show the pack itself – the bottle – or they may show the product ready for use, in a glass. What is more, the bottle may be dark, in which case the colour of what is inside may be hard to see, or it may be clear, and therefore the colour of the contents is critical. In a glass, the contents will normally be paramount.

If you need to show the colour of the contents, some form of transillumination is essential, and it is interesting to see the variety of ways in which this problem has been solved. And, of course, lighting glass itself can be a difficult technical exercise. The solutions are right here.

Photographer: **Jonathan Knowles**

Client: **United Distillers**

Use: **Promotional**

Camera: **8x10 inch**

Lens: **300mm**

Film: **Fuji Velvia**

Exposure: **f/64: shutter speed not recorded.**

Lighting: **Mixed: Electronic flash (1 head),
tungsten (1 head), light brush and reflectors.**

Props & set: **Hired props from prop house:
Barrels, corn, barley and window.**

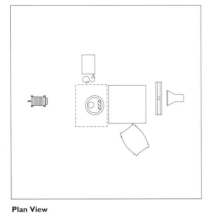

Plan View

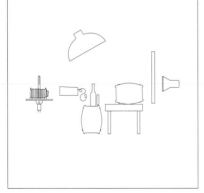

Side View

▼

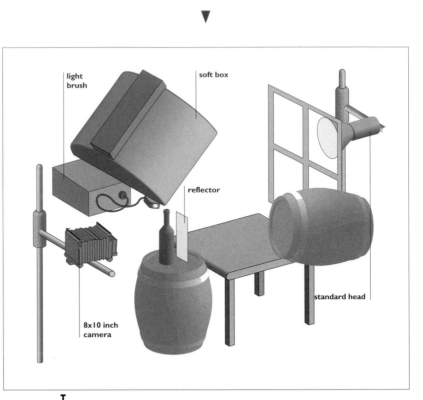

T<small>HIS OPENING SHOT IN THE BOOK SHOWS HOW A SKILLED PRODUCT
PHOTOGRAPHER WORKS. IT BEGAN WITH THE IDEA OF THE BOTTLE STANDING ON A BARREL;
THE OTHER BARRELS AND THE WINDOW WERE SET "TO CAMERA" — IN OTHER WORDS, TO
COMPLETE THE SCENE FROM THE CAMERA'S VIEWPOINT.</small>

Then came the lighting. The key light is effectively the light brush, which was used to light the bottle and the white reflector behind it which gives the transilluminated glow, as well as to "touch up" other parts of the set. A 1K tungsten light through the "window" (which was actually suspended, and is not set in a wall) provided the warm daylight glow. A small soft box, above the middle of the set, and pointing rearwards, provided the fill light; smoke from a fog machine added atmosphere and diffused the background while leaving the bottle needle sharp; shooting on 8x10 inch further emphasized this sharpness.

The technique of lighting a reflector behind the bottle with a light brush is particularly noteworthy. It could easily look unnatural, but here it is superbly executed.

Photographer's comment:

The bottle is quite brightly lit whilst managing to keep the surroundings quite moody.

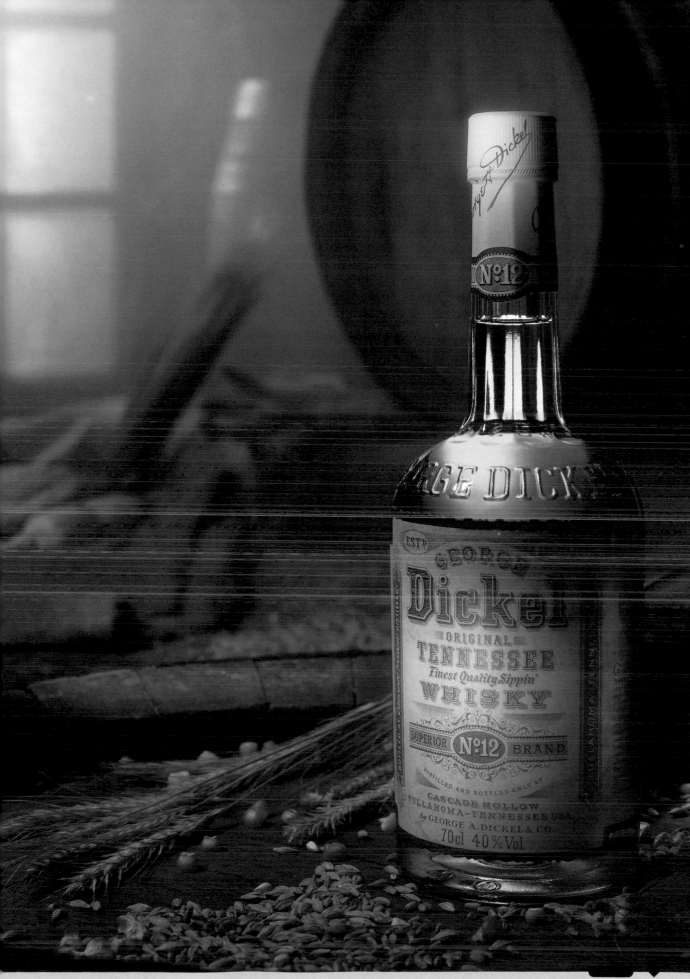

BOTTLES

▼

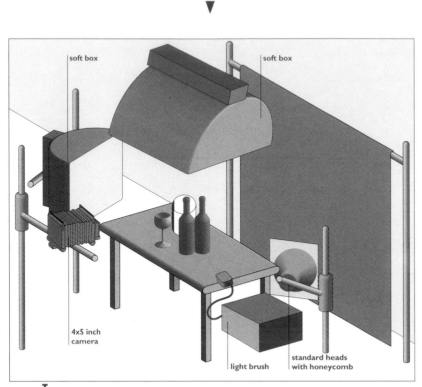

Photographer: **Massimo Robecchi**

Client: **Seagram Italy**

Use: **Calendar**

Stylist: **Teresa La Grotteria**

Art director: **Massimo Cecchi (Agency Milano & Grey)**

Camera: **4x5 inch**

Lens: **300mm, with soft filter for part of exposure.**

Film: **Kodak Ektachrome EPP**

Exposure: **f/32 and f/8 (double exposure) plus some minutes for light brushing**

This shot took about 35 minutes to expose, using two exposures and a light brush. The first exposure was f/8 for the background, with only the background light switched on. The second exposure, at f/32, was made with the background covered in black cloth to avoid spill from the other lights.

The two soft boxes provided the fill (though the terms "fill" and "key" are not always meaningful when you use a light brush) and the light brush was used as shown in the accompanying diagram:

(1) Right bottleneck, 30 seconds with amber filter. (2) Left bottleneck, 45 seconds with light blue filter. (3) Tablecloth, 15 seconds with dark blue filter. (4) Coffee grinder body, 60 seconds no filter. (5) Coffee grinder top, 30 seconds no filter. (6) Tablecloth, 5 seconds, amber filter on light, soft filter on lens. (7) Leaf, (8) 20 seconds no filter. Left bottle, 15 seconds no filter. (9) Right bottle, 30 seconds no filter.

Photographer's comment:

Two shots, a light brush and a few minutes to make some typical Italian products look appetizing.

Lighting: **Electronic flash (2 heads, 1 soft box, 1 diffused) and light brush with filtration.**

Props & set: **Tablecloth, grapes, coffee grinder. Background is a plywood wall covered in wallpaper.**

Lighting Areas

Side View

Plan View

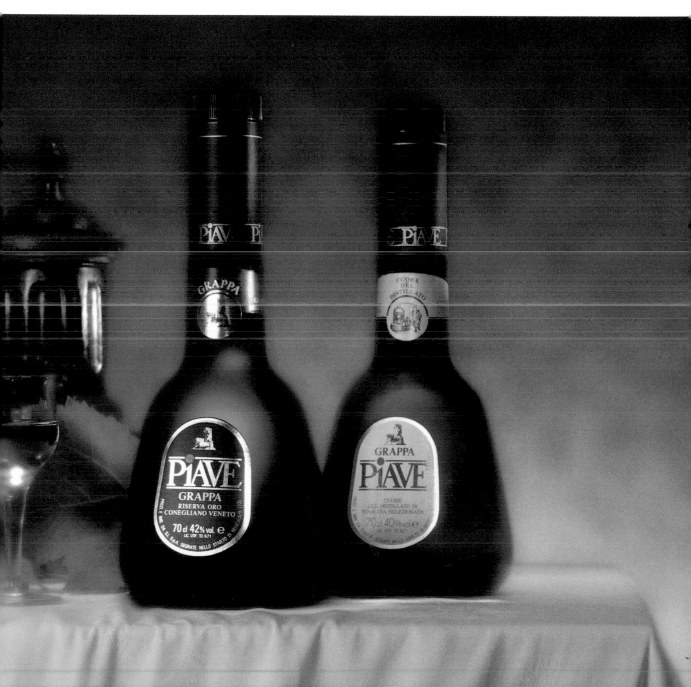

Photographer: **Raymond Tan**

Use: **Self-promotional shot**

Camera: **4x5 inch**

Lens: **210mm**

Film: **Fuji RDP**

Exposure: **f/11**

Lighting: **Electronic Flash: 2 heads. 1 soft box,
1 diffused head with standard reflector. 1
silver bounce.**

Props & set: **Bottle and box**

Plan View

Side View

▼

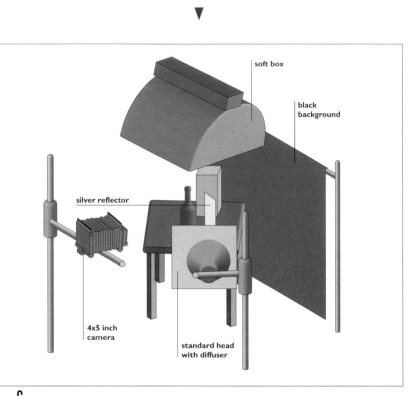

soft box

black
background

silver reflector

4x5 inch
camera

standard head
with diffuser

Sᴜʙꜱᴛᴀɴᴛɪᴀʟʟʏ ᴛʜᴇ ꜱᴀᴍᴇ ꜱᴜʙᴊᴇᴄᴛ ᴀꜱ ᴛʜᴇ ꜱʜᴏᴛ ᴏɴ ᴘᴀɢᴇ 18/19 — Sᴄᴏᴛᴄʜ ᴡʜɪꜱᴋʏ
ɪɴꜱᴛᴇᴀᴅ ᴏꜰ Tᴇɴɴᴇꜱꜱᴇᴇ, ɪᴛ ɪꜱ ᴛʀᴜᴇ — ʙᴜᴛ ᴡɪᴛʜ ᴀ ᴠᴇʀʏ ᴅɪꜰꜰᴇʀᴇɴᴛ ᴛʀᴇᴀᴛᴍᴇɴᴛ. Nᴏᴛᴇ ʜᴏᴡ
ᴛʜᴇ ᴀᴘᴇʀᴛᴜʀᴇ ɪꜱ ᴄʜᴏꜱᴇɴ ᴛᴏ ᴀʟʟᴏᴡ ᴛʜᴇ ʙᴏx ɪɴ ᴛʜᴇ ʙᴀᴄᴋɢʀᴏᴜɴᴅ ᴛᴏ ʀᴇᴀᴅ, ʙᴜᴛ ᴏɴʟʏ ᴊᴜꜱᴛ.

Raymond Tan used two lights: a soft box
overhead and slightly behind the subject,
and a diffused standard head to camera
left and in front. The lighting ratio is very
close: the shadows from the key (the
overhead soft box) are very soft. The
emphasis is very much on the shape of
the bottle, with a beautifully lit
combination of highlighted and dark
edges. A reflector behind the bottle

takes care of transillumination and the
black background contributes to the
dark edges of the bottle.

A temptation to the novice is to
make do with a single large soft box,
but this picture illustrates well the
advantages of being able to use a small
soft box instead; note those edge
shadows on the bottle.

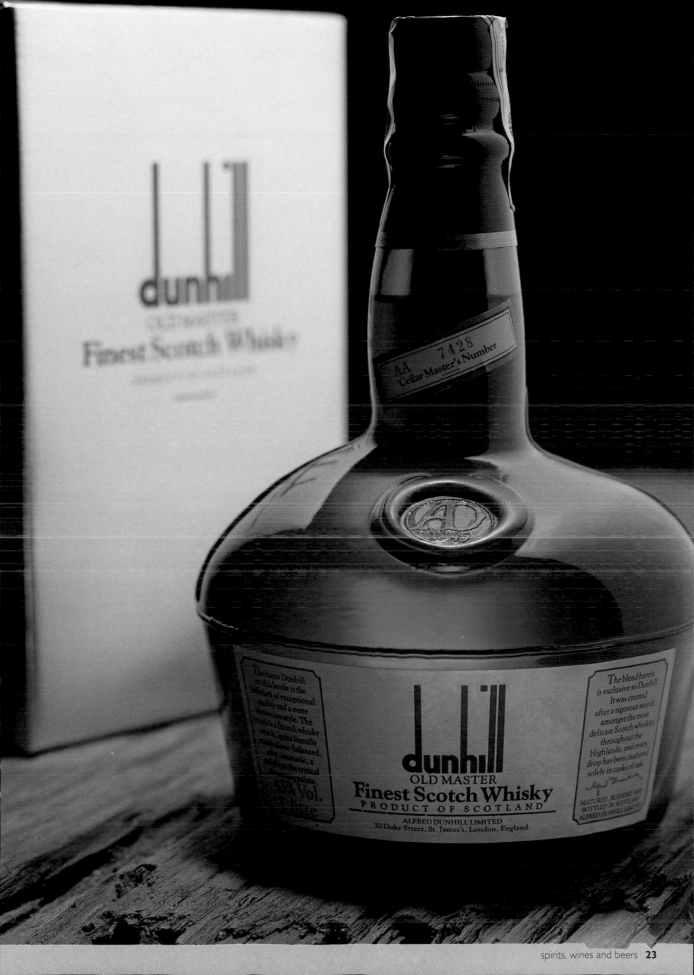

Photographer: **Robert Stedman**

Client: **Crawfurd's Tropical Cocktail Co.**

Use: **Brochure and poster**

Camera: **4x5 inch**

Lens: **210mm**

Film: **Kodak Ektachrome EPP 100**

Exposure: **f/32**

Lighting: **Electronic flash: 2 heads**

Props & set: **Acrylic ice resting on glass sheet with tracing paper**

Plan View

Side View

GIN SLING

▼

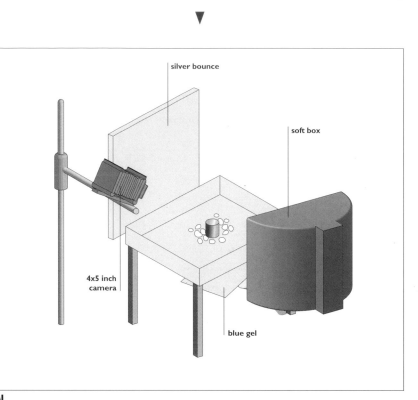

NOTHING ABOUT THIS SHOT IS QUITE WHAT IT SEEMS. THE CAN WAS CUSTOM MADE; THE ICE IS OF COURSE ACRYLIC, RATHER THAN ACTUAL ICE; AND EVEN THE MOISTURE ON THE CAN IS NOT WATER, BUT A SPECIALLY MADE "DEW" MIXTURE.

The lighting is however relatively straightforward. A glass sheet lined with tracing paper provides the ground, on which the "ice" and the can are laid. The ground is transilluminated by a small standard head below the set, with a weak blue gel to make the whole set look even colder.

The upper part of the set is lit with a medium-size soft box about 50cm (20inches) from the can, to camera right; a large matte silver bounce opposite the soft box, to camera left, evens out the light still more. A silver reflector is of course more reflective than a white bounce, but more directional. With the light and bounce in place, it was a matter of moving them slightly until the can looked rounded and well differentiated from the "ice".

Photographer's comment:

The client wanted to portray the cool nature of his product. Shooting on ice was a natural. Silver and plastic ice are tough to shoot.

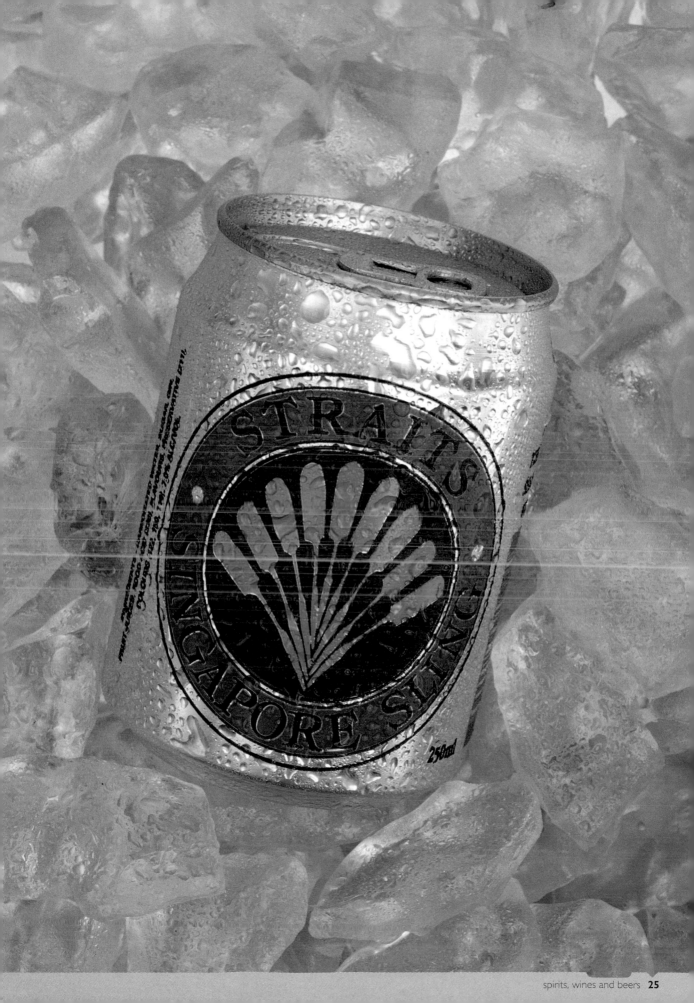

Photographer: **Stefano Zappalà, Green &
Evergreen S.A.S**

Client: **Portfolio/personal research**

Camera: **8x10 inch**

Lens: **360mm with diffusers**

Film: **Kodak Ektachrome 64T**

Exposure: **4x16 seconds (quadruple exposure)
at f/45**

Lighting: **Tungsten: 500w spots**

Props & set: **Background hand-coloured with
pastels**

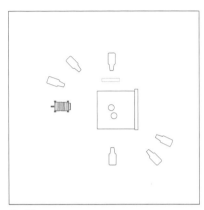

Plan View

Side View

▼

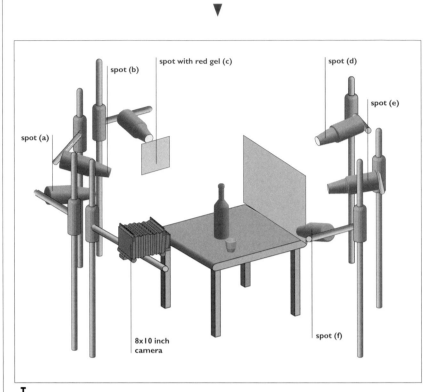

spot (b)

spot with red gel (c)

spot (d)

spot (e)

spot (a)

8x10 inch
camera

spot (f)

THE COLOUR OF CAMPARI IS INSTANTLY RECOGNIZABLE – BUT HOW DO YOU GO BEYOND A MERE FORMAL REPRESENTATION? STEFANO ZAPPALÀ USED A COMPLEX LIGHTING SET-UP, PLUS VARYING DEGREES OF DIFFUSION IN THE IMAGE, TO ACHIEVE THE DESIRED RESULT.

The first exposure – effectively the key, as it creates the principal highlights and shadows – uses spotlights A and B to illuminate the left side of the bottle. The second exposure uses C, with a red gel, to create the colour in front of the bottle. The third uses D and F to transilluminate the bottle and the glass, and the fourth uses E to create the highlights in the ice and the focused spot of light in front of the glass. A slight diffuser was used on the first, second and fourth exposures; a stronger diffuser on the third.

For any given exposure, only one or two lights are used, though it would of course be easier to have all six in position and to switch them on and off as required.

Photographer's comment:

*There is an interesting contrast between the soft tonalities of the hand-painted background
and the sharpness and intensity of colour in the bottle and the liquid.*

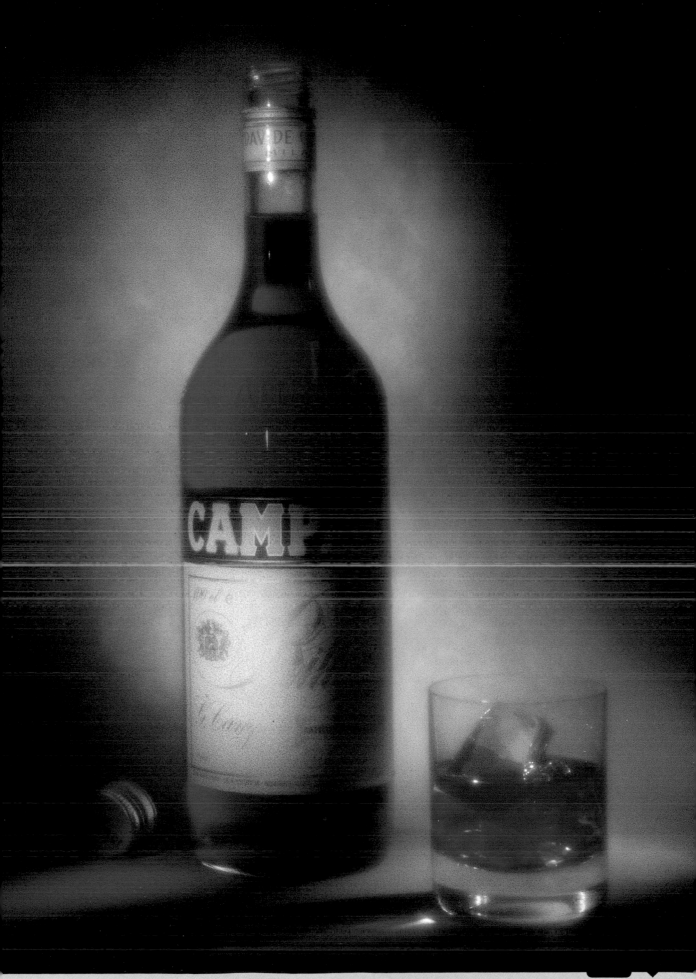

STELLA DRY [BLUE]

Photographer: **Jonathan Knowles**

Client: **FKB & Associates**

Use: **Promotional shot**

Art director: **Marcos Quinn**

Camera: **8x10 inch**

Lens: **300mm**

Film: **Fuji Velvia**

Exposure: **f/32**

Lighting: **Electronic flash (1 soft box) and light brush**

Props & set: **Background is blue gel through Perspex**

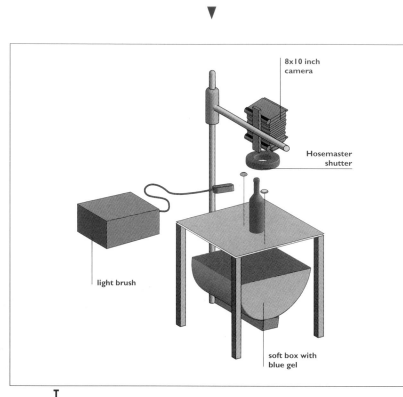

THIS IS A SIMPLE SHOT — ONCE YOU KNOW HOW IT WAS DONE. TIME AND AGAIN, DRAMATIC SHOTS PROVE TO BE SURPRISINGLY SIMPLE IN THEORY, IF NOT NECESSARILY IN EXECUTION: MAKING SOMETHING WORK CAN OFTEN BE AS DIFFICULT AS DEVISING THE IDEA IN THE FIRST PLACE.

The background is a sheet of Perspex (methyl methacrylate) with a blue gel on top. A hole in the blue gel allows the bottle to retain its green colour, and the beer to remain golden; cutting holes for this sort of thing can be very time consuming. A big soft box under the set provided the illumination.

The two "floating" bottle-caps were supported on wires coming straight up from the background, and therefore concealed from the camera by the caps themselves. A Hosemaster light brush was used to "paint" the three caps (the one on the bottle and the two others); and that's all there was to it. Simple — once you have had the original idea and worked out how to realize it.

Photographer's comment:

Graphic simplicity with intrigue caused by floating caps.

Side View Plan View

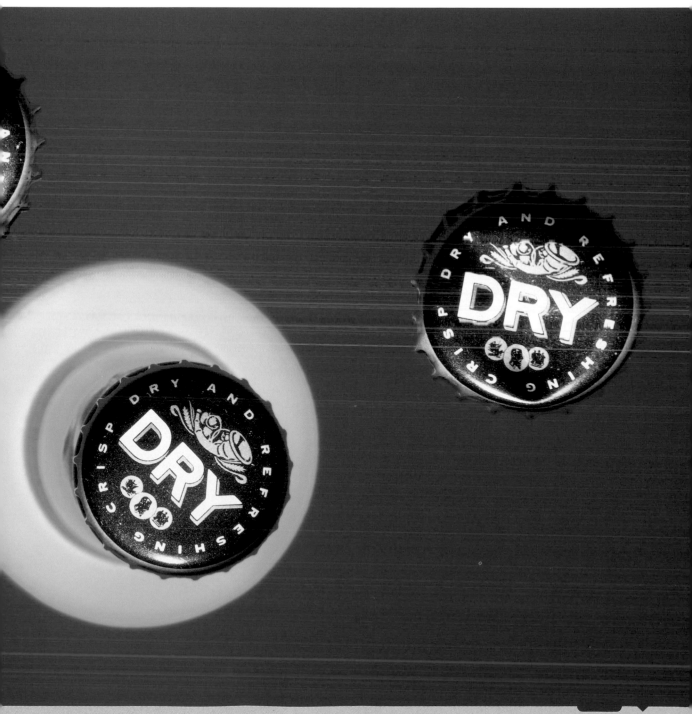

Photographer: **Fabrizia di Rovasenda**

Client: **Gancia**

Use: **Magazine advertising**

Camera: **4x5 inch**

Lens: **150mm**

Film: **Kodak Ektachrome EPP 100**

Exposure: **f/22**

Lighting: **Electronic flash: 2 heads**

Props & set: **Tank full of Gancia,
plastic-coated label**

Plan View

Side View

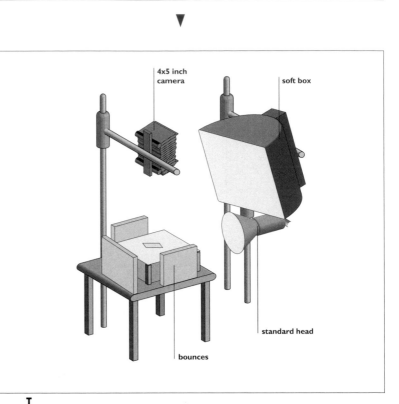

▼

THERE IS A LIMIT TO THE NUMBER OF WAYS IN WHICH YOU CAN SHOW A
DRINK IN A BOTTLE, OR IN A GLASS — BUT THIS GOES BEYOND THE TRADITIONAL
WAYS OF REPRESENTING A SPARKLING WINE.

The label, plastic coated to stop it going soggy, rests on concealed supports in the middle of a 50x70cm (19x28inch) tank filled with Gancia sparkling wine. The tank is surrounded with expanded polystyrene reflectors, except on the side where it is lit with a 600ws standard head to illuminate the bubbles. Overall light comes from a soft box which lights the tank of wine from the side and casts the soft shadow under the label: the camera is shooting straight down, so terms such as "camera left" and "camera right" have little meaning.

Apart from the inevitable logistical difficulties, the real problem in a shot like this lies in rendering the bubbles convincingly; the side light does this very well.

Photographer's comment:

The elimination of any visible container shows the product better and more elegantly.

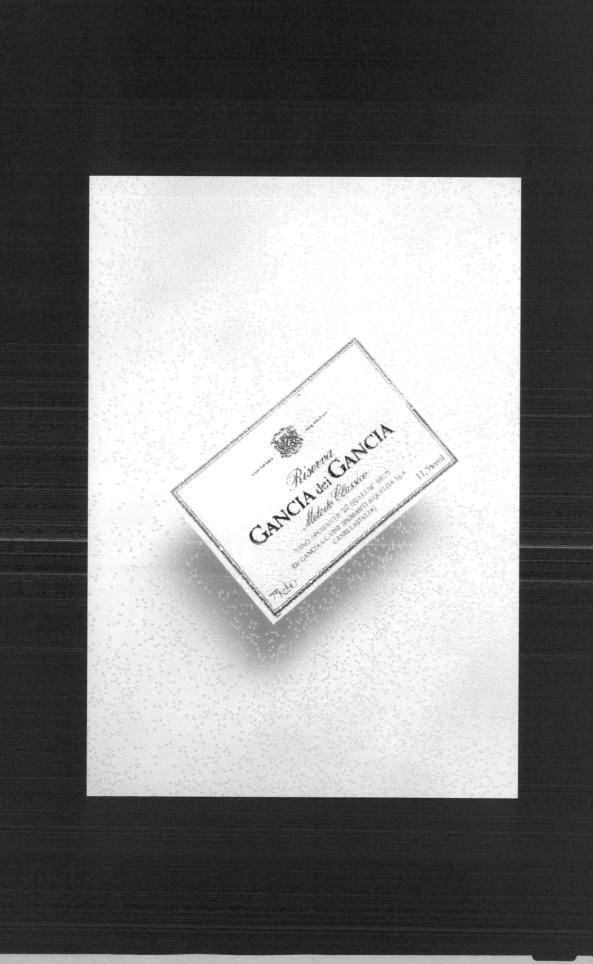

Photographer: **Mario Candelarezi**

Camera: **4x5 inch**

Lens: **300mm**

Film: **Kodak Ektachrome 64T**

Exposure: **Not recorded**

Lighting: **Electronic flash: 3 heads. 1 standard reflector: 2 soft boxes, 1 with extra diffusion.**

Props & set: **Table, painted backdrop.**

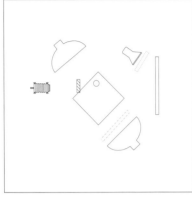

Plan View

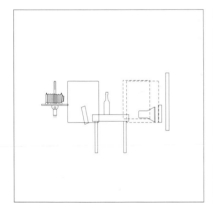

Side View

▼

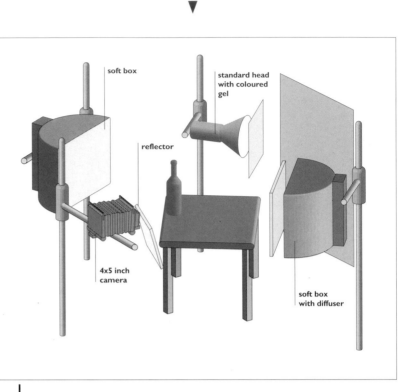

soft box

standard head with coloured gel

reflector

4x5 inch camera

soft box with diffuser

Lighting a bottle on the corner of a table is something of a nightmare: a typical example of a very simple shot which mercilessly shows up any technical defects or flaws in the bottle. You just need to be very, very careful.

The process begins with finding the best bottle possible: not just a perfect label, but glass with no scratches or nicks. The actual lighting on the bottle consists of two soft boxes, one to camera left and in front of the subject, and one to camera right and behind the subject (with an extra diffuser), together with a white card reflector immediately below the camera to throw some more light onto the label.

Because the two main lights are soft boxes, they can be balanced for a 1:1 lighting ratio without worrying about shadows. Using one in front of the bottle and one behind creates a real sense of modelling, and also allows some of the light to transilluminate the wine. The backdrop is lit and coloured by a single light with a coloured gel.

Photographer's comment:

This is a straightforward shot which relies on a combination of soft and hard lighting combined; the light through the bottle, and the hard edges.

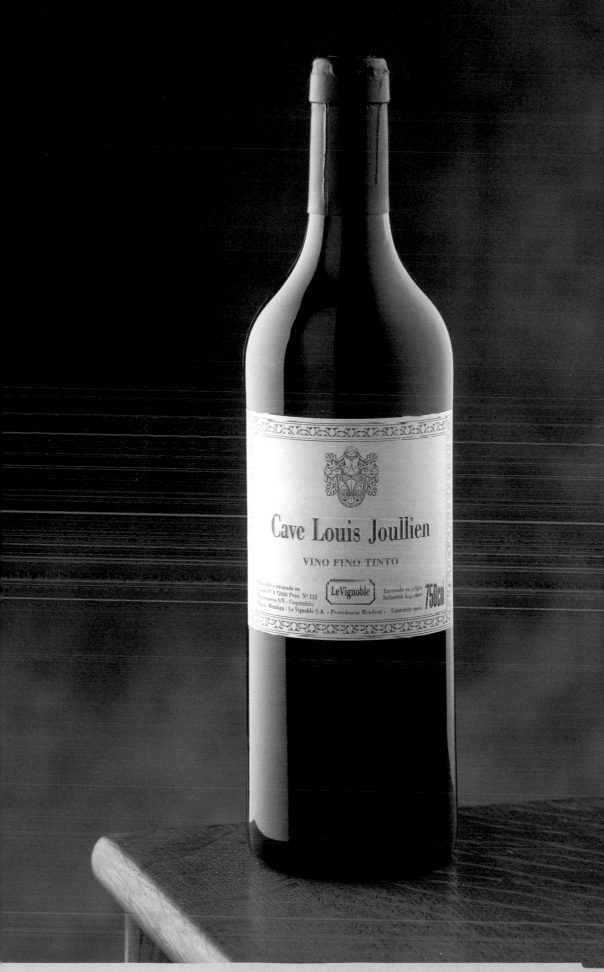

2 jewellery

and clothing

We all judge, and are judged, by external appearances. Different people form their judgements in different ways. One may be impressed by expensive, well-polished shoes, even if the person wearing them is otherwise casually or even scruffily dressed. Another may look first at jewellery. Yet a third might note that the person was carrying an expensive briefcase. Then there is always the "designer label", where the signature of some well-known designer is often more important than what they have designed.

Ideally, of course, we would all like to be well turned out in all ways at all times; but we know that this is not going to happen. We therefore choose our clothing and accessories for different occasions in different ways. Advertising jewellery, clothing and the like is therefore a little different from advertising (say) whisky, which is only a small part of our lives and one which is not normally on display to the world at large.

However, because clothes and jewellery are so everyday, they can be hard to illustrate: what can there be new to say? The choice is between the straight product shot, where the goods are left to speak for themselves, and the more emotive shot where the picture tries to imply more than is immediately present on the surface.

Photographer: **Terry Tsui**

Client: **Kenny Jewellery**

Use: **Magazine advertising**

Art director: **Gary Leung**

Camera: **4x5 inch**

Lens: **240mm**

Film: **Fuji RDP 100**

Exposure: **f/32-1/2 (f/39)**

Lighting: **Electronic flash: 6 heads, plus 6 mirrors.**

Props & set: **Frame, green paper, tissue paper, fabric.**

Plan View

Side View

EMERALDS

▼

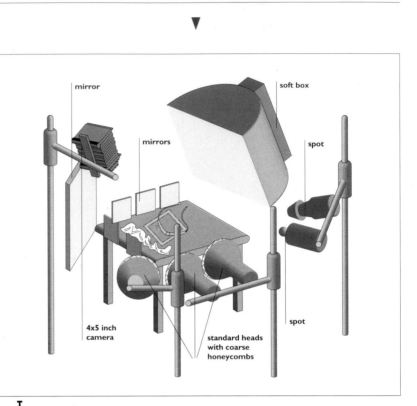

TERRY TSUI ILLUSTRATES HOW TO GET THE BALANCE RIGHT IN SHOOTING JEWELLERY: A SOFT ENOUGH OVERALL LIGHT TO REVEAL ALL THE DETAILS AND TEXTURES, PLUS ENOUGH EFFECTS LIGHTS TO CREATE HIGHLIGHTS AND SPARKLES WHERE THEY ARE NEEDED. AS WELL AS FIVE EFFECTS LIGHTS, THERE ARE SIX MIRRORS.

The main light — with that many effects lights, is hardly a true key — is a 100x100cm soft box above and behind the set. A snooted spot to camera right, also a back light, provides some of the highlights. A bare head flash, with no reflector, provides the nearest you can get to a point source from electronic flash; this is essential for "fire" in the stones. Three more effects lights, all in standard reflectors and fitted with medium and coarse honeycombs, are positioned to camera right, and then there are no fewer than six mirrors which function as additional effects lights. The soft box is not so much a key as a means of killing the innumerable crossed shadows which would otherwise result from using eleven lights.

Photographer's comment:

The most difficult thing is how to show the true colour of the stones. Lighting must be very carefully set up.

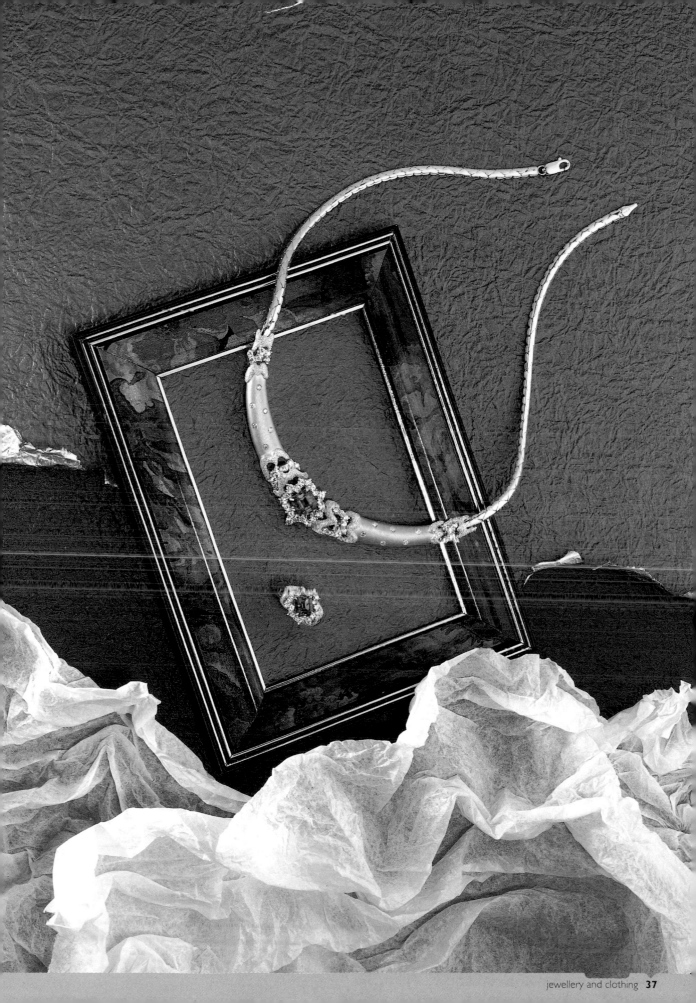

Photographer: **José Antonio Egea**

Client: **Candame SA**

Use: **Magazine advertising**

Camera: **4x5 inch**

Lens: **210mm**

Film: **Kodak Ektachrome 64**

Exposure: **f/32**

Lighting: **Electronic flash: 3 heads**

Props & set: **Translucent painted paper background**

Plan View

Side View

▼

soft box

standard head with green gel

spot

green gel

4x5 inch camera

bounce

Sₘₐₗₗ SIZE AND INTRICACY ARE A MAJOR PART OF THE ATTRACTION OF MANY KINDS OF JEWELLERY, BUT THEY CAN LEAD TO THEIR OWN PROBLEMS FOR THE PHOTOGRAPHER WHO MUST LIGHT A TINY SUBJECT AS CAREFULLY AS A LARGE ONE.

Sr. Egea overcame the problems in several ways. Firstly, the earring is supported on a wire some 40cm (15 inches) in front of the background, which is of extremely thin paper painted with black watercolour paint to create the intriguing texture. The colour in the background comes from a green gel over the 800ws standard head with which it is transilluminated. A 1600ws hazy lamp (soft box) above the subject provides the overall illumination, while an 800ws snooted standard head adds sparkle to the highlights and such "fire" as can be attained with small stones; bigger stones obviously sparkle more, though it is worth remembering that true sparkle and "fire" in precious stones comes from movement and can never be fully captured in a still picture.

Photographer's comment:

I wanted to photograph the earring on its own, without its twin, to emphasize its beauty and to reinforce the idea of its uniqueness. The client gave me a completely free hand to interpret the subject.

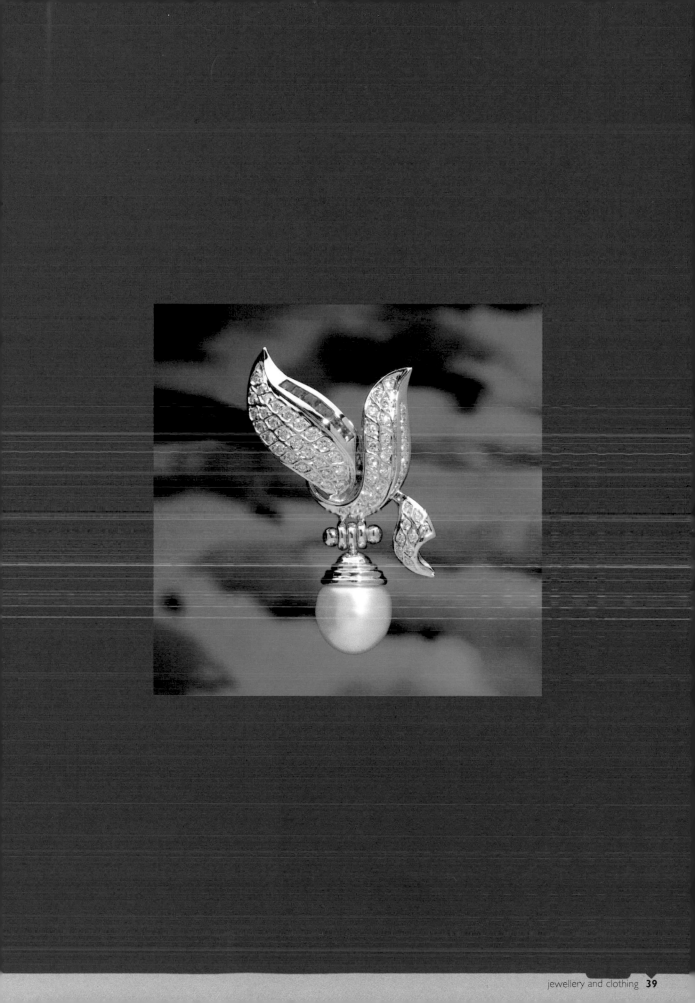

Photographer: **Coskun Ipek**

Client: **Goldag**

Art director: **Getin Özer**

Camera: **4x5 inch with 6x7cm back**

Lens: **150mm**

Film: **Fuji RVP ISO 50**

Exposure: **f/22**

Lighting: **Electronic flash: 1 soft box.**

Props & set: **Stone and dry rose petals**

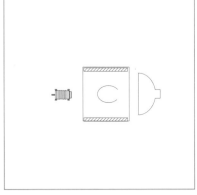

Plan View

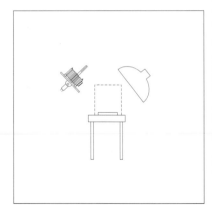

Side View

HEART

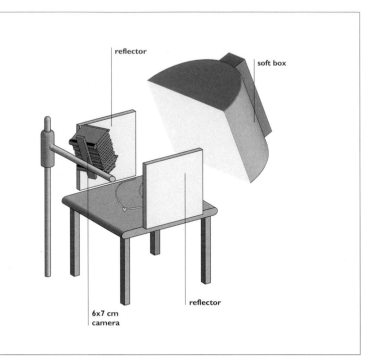

Uɴᴇxᴘᴇᴄᴛᴇᴅʟʏ, Cᴏsᴋᴜɴ Iᴘᴇᴋ ᴜsᴇᴅ ᴏɴʟʏ ᴀ sᴏғᴛ ʙᴏx ᴛᴏ ʟɪɢʜᴛ ᴛʜɪs ʟɪᴛᴛʟᴇ
ᴅɪᴀᴍᴏɴᴅ-sᴛᴜᴅᴅᴇᴅ ʜᴇᴀʀᴛ. Iɴsᴛᴇᴀᴅ ᴏғ "ғɪʀᴇ", ʜᴇ ᴄʀᴇᴀᴛᴇᴅ ᴀ ʙʀɪʟʟɪᴀɴᴛ ᴡʜɪᴛᴇɴᴇss ᴡʜɪᴄʜ
ᴄᴏɴᴛʀᴀsᴛs sᴜᴘᴇʀʙʟʏ ᴡɪᴛʜ ᴛʜᴇ sᴛᴏɴᴇ ʙᴀᴄᴋɢʀᴏᴜɴᴅ ᴀɴᴅ ᴛʜᴇ ᴅʀɪᴇᴅ ʀᴏsᴇ ᴘᴇᴛᴀʟs;
ᴀɴ ɪᴍᴀɢᴇ ᴏғ ʙʀɪɢʜᴛ ᴀɴᴅ ᴛɪᴍᴇʟᴇss ʟᴏᴠᴇ.

"Flat" lighting like this is normally the last thing you want in jewellery photography: a soft box above and behind the subject, together with reflectors on either side. However, the reason it is successful in this case is due to the contrast of textures: the bright, shiny gold and diamonds of the pendant against the matte, soft colours of the stone and the dried flowers. A harder light would have destroyed the delicacy of the rose petals and the subtlety of the stone without adding anything to the texture of the jewellery.

The choice of Fuji Velvia in a 6x7cm back on a 4x5 inch camera is interesting: Velvia is known for its very strong colour saturation, but needs to be used in flat, soft lighting if contrast is not to become a problem.

Photographer's comment:

The choice of accessories was made to relate the feelings and ideas linked to the subject.

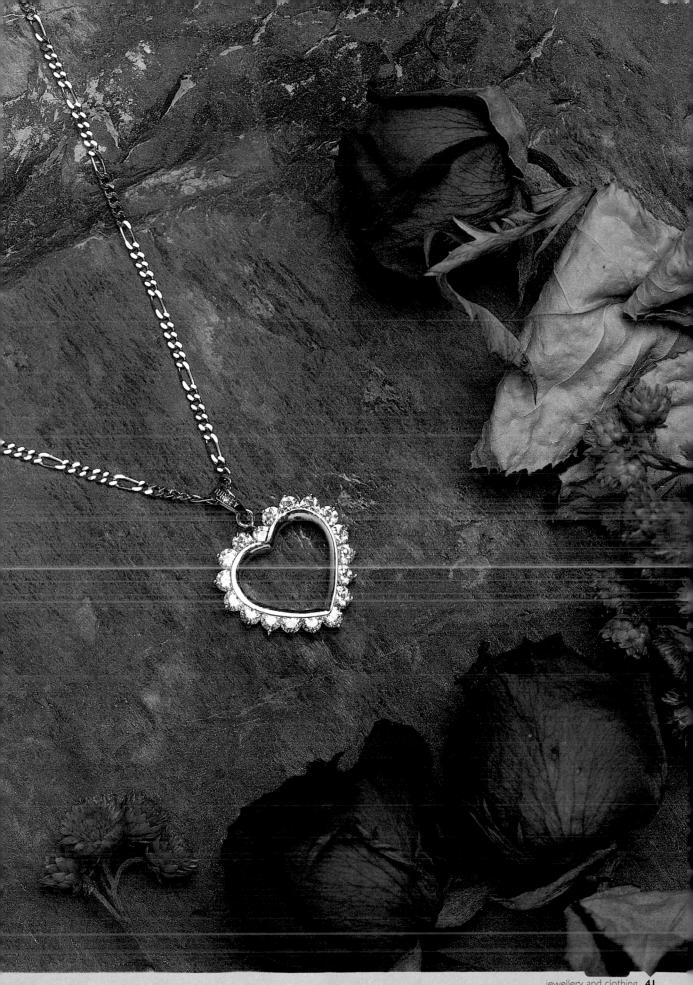

Photographer: **Manuel Fernandez Vilar**

Client: **Hergar**

Use: **Advertising, magazines & posters**

Camera: **4x5 inch**

Lens: **360mm**

Film: **Kodak Ektachrome 64**

Exposure: **f/32**

Lighting: **Electronic flash: 2 heads**

Props & set: **Daisy; acrylic background**

Plan View

Side View

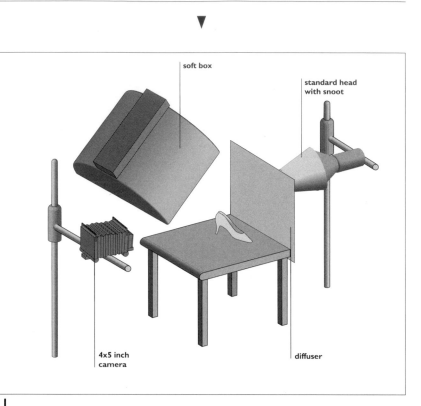

INHERENTLY, A SINGLE SHOE — EVEN A SHOE SO ELEGANT AS THIS ONE — IS AN UNPROMISING SUBJECT. BUT BY DRAMATIC USE OF CONTRASTING COLOURS, AND BRILLIANT USE OF REFLECTION, THE PHOTOGRAPHER HAS TRANSFORMED IT INTO A SUPERB STILL LIFE.

The shoe is stood on one piece of blue acrylic material, with a background of another. The line between the two is more dramatic than a single, curved piece of acrylic could have been. The lighting is extremely simple. To illuminate the shoe, there is a large soft box above the subject and to camera left, while the acrylic background is transilluminated by a snooted standard head: the snoot creates the circle of light. That is all.

Often, with pictures like this, you find that the basic concept (in this case, the reflection and contrasting colours) works well enough, but that adding an additional design component (in this case, the daisy) makes it something really special. It is sometimes a question of trying different props until something looks exactly right.

Photographer's comment:

I wanted to emphasize the elegance of the line, and the slenderness of the shoe.

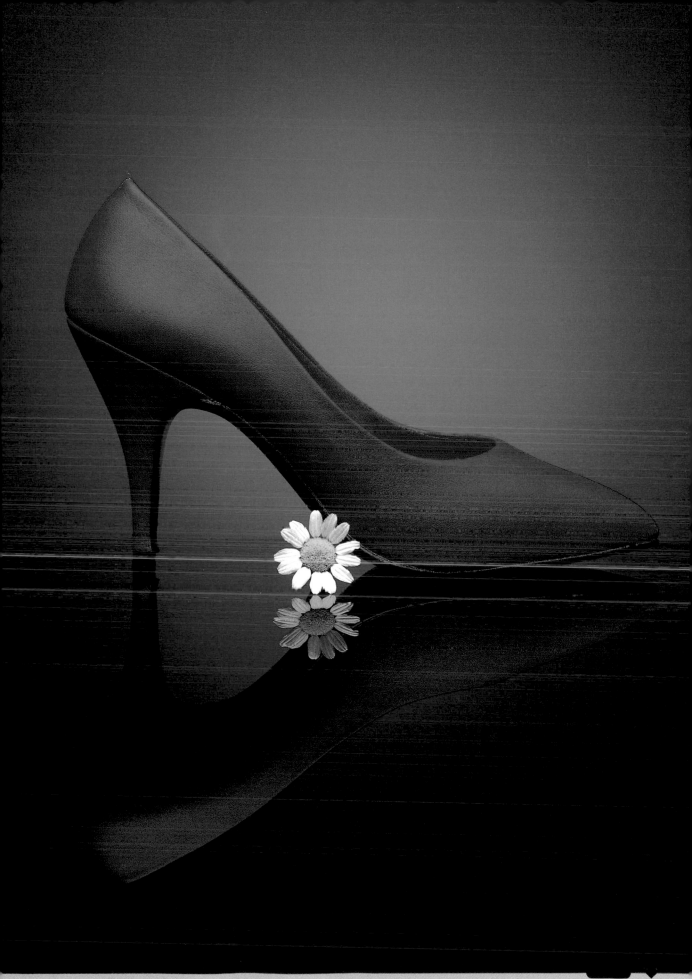

Photographer: **Artli Ali Hawijono**

Client: **JJ Jeans**

Use: **Advertising**

Camera: **4x5 inch**

Lens: **90mm with soft focus screen**

Film: **Fuji ISO 100**

Exposure: **f/32**

Lighting: **Light brush**

Props & set: **In-house studio props and rusty steel background**

Plan View

Side View

▼

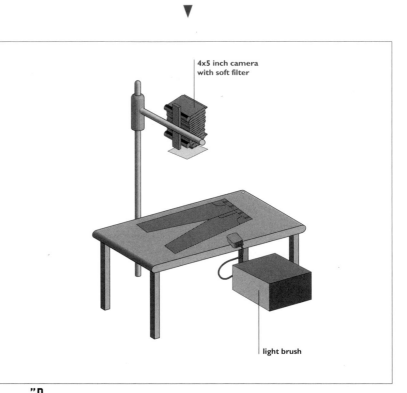

4x5 inch camera with soft filter

light brush

"P"URE" LIGHT-BRUSHING — USING THE LIGHT BRUSH AS THE ONLY SOURCE, WITHOUT ANY ELECTRONIC FLASH TO SUPPLEMENT IT — IS VERY UNUSUAL; BUT ARTLI ALI HAWIJONO IS A MASTER OF THE LIGHT BRUSH, AND USES IT IN MANY WAYS.

The classic problem with the light brush is that the photographer must have a very clear visual image of what is needed, along with a flawless memory of what he or she has already brushed. Although there is no true "key" in this picture — the light brush was used from all directions — there is nevertheless an overall feeling of lighting from the left, almost as if from a point source coinciding with the notch in the centre left of the background. There is a consistent shadow along the right side of the jeans, which is prolonged upwards on the top right and downwards on the bottom right. It is an effect which would be extraordinarily hard, indeed probably impossible, to recreate using any other form of lighting.

Photographer's comment:

The detail of the background and texture of the jeans blend well, making an interesting combination.

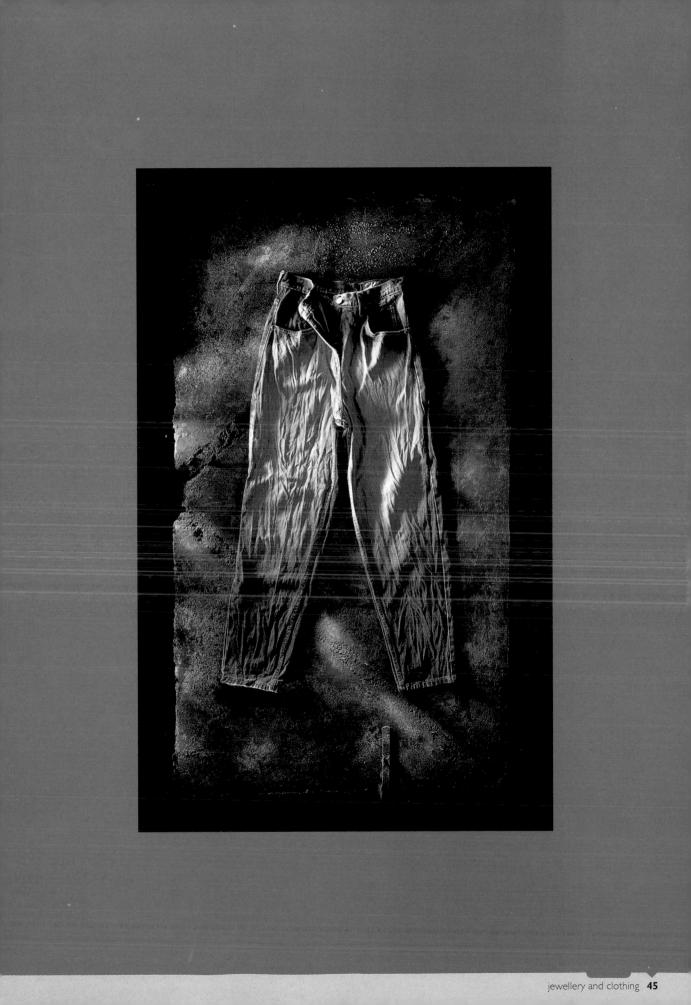

Photographer: **Robert Stedman**

Client: **Bonia Fashions**

Use: **Advertising**

Camera: **4x5 inch**

Lens: **180mm**

Film: **Kodak Ektachrome EPY ISO 64**

Exposure: **f/22: shutter speed not recorded.**

Lighting: **Tungsten, single head.**

Props & set: **Plywood sheet with dried
leaves/flowers.**

Plan View

Side View

S H O E S

▼

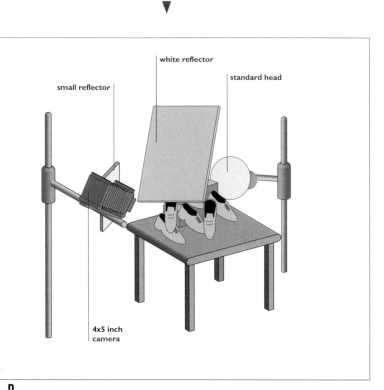

ROBERT STEDMAN HAS A PREDILECTION FOR USING SINGLE LIGHT SOURCES,
WHICH MAY BE WHY HIS PICTURES OFTEN LOOK SO NATURAL. HOWEVER, THIS IS A DEFINITIVE
PRODUCT SHOT, COMPLETE WITH THE BOX IN THE BACKGROUND. CAREFUL SET BUILDING, AND
JUDICIOUS CHOICE OF PROPS, MAKE IT VERY ATTRACTIVE.

The key (and indeed only) light is a tungsten head behind and to the left of the subject, bounced off a 120x240cm styrofoam reflector board to camera right; this reflector provides the broad highlights on the toes of the shoes while still allowing the colours of the leather to show through. A smaller reflector card to camera left provides a little extra fill to stop the shadows going too dark.

When you are dealing with reflective surfaces such as polished leather, even quite weak reflectors can prove very effective, because they do not just push light into the shadows: they are themselves reflected in the polished surfaces. Also, tungsten lighting gives a different "feel" from flash which Robert felt was more appropriate for this subject.

Photographer's comment:

The client wanted to portray a natural theme. A classic product shot.

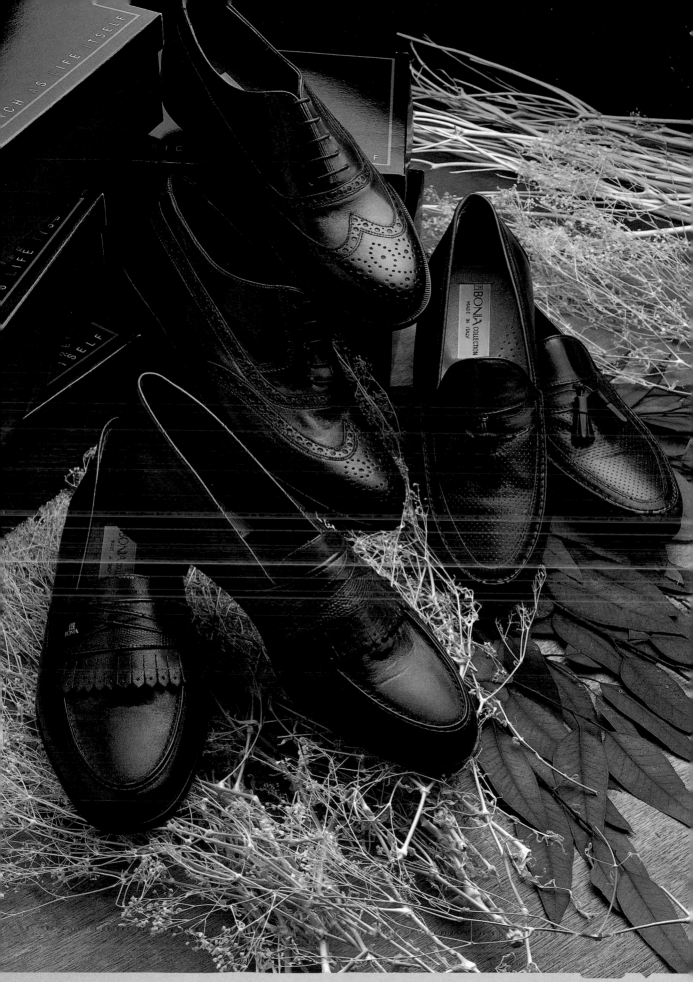

CASE

▼

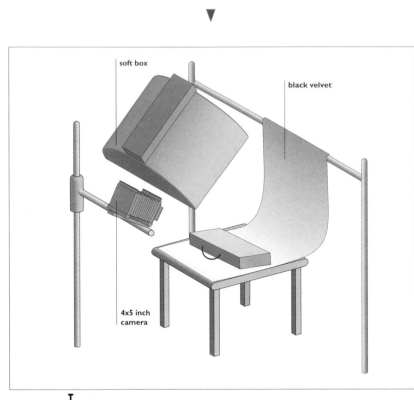

soft box

black velvet

4x5 inch
camera

Photographer: **Artli Ali Hawijono**

Client: **President Travel Ware**

Use: **Calendar**

Camera: **4x5 inch**

Lens: **210mm**

Film: **Fuji**

Exposure: **f/32**

Lighting: **Electronic flash (soft box) and light brush**

Props & set: **Specially-made painting (in-house artist)**

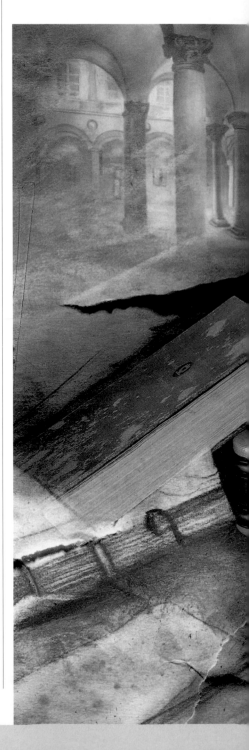

Tʜɪs ɪs ᴀᴄᴛᴜᴀʟʟʏ ᴀ ᴛʀɪᴘʟᴇ ᴇxᴘᴏsᴜʀᴇ, ᴜsɪɴɢ Aʀᴛʟɪ Aʟɪ Hᴀᴡɪᴊᴏɴᴏ's sɪɢɴᴀᴛᴜʀᴇ ᴛᴇᴄʜɴɪ϶ᴜᴇ ᴏꜰ ʟɪɢʜᴛ-ᴘᴀɪɴᴛɪɴɢ ꜰᴏʀ ᴛʜᴇ sᴇᴄᴏɴᴅ ᴛᴡᴏ ᴇxᴘᴏsᴜʀᴇs. A ʙʟᴀᴄᴋ ᴠᴇʟᴠᴇᴛ ʙᴀᴄᴋɢʀᴏᴜɴᴅ (ᴡʜɪᴄʜ ʀᴇᴄᴏʀᴅs 5 sᴛᴏᴘs ᴅᴏᴡɴ ꜰʀᴏᴍ ᴀɴ 18 ᴘᴇʀ ᴄᴇɴᴛ ɢʀᴇʏ) ᴍᴀᴅᴇ ᴛʜᴇ ᴍᴜʟᴛɪᴘʟᴇ ᴇxᴘᴏsᴜʀᴇ ᴘᴏssɪʙʟᴇ.

The first exposure was the easy one: the case, and the book which rests on its left side. This was made conventionally, using a large soft box above and in front of the subject. Then the fun started.

The second exposure was of a painting of old books, simply superimposed on the first. You can actually see the right-hand side of the case through one of the books, but you have to look for it; it just looks like a part of the painting.

The third exposure, of another painting, explains the arches in the upper left-hand corner of the image. Both paintings were made by an in-house artist.

The advantage of using a light brush for multiple exposures is that highlights can be added, and shadows deleted, almost at will — provided you know how to use it.

Photographer's comment:

Classic, abstract.

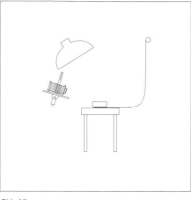

Side View

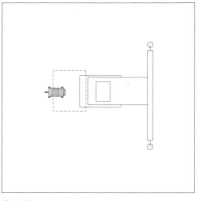

Plan View

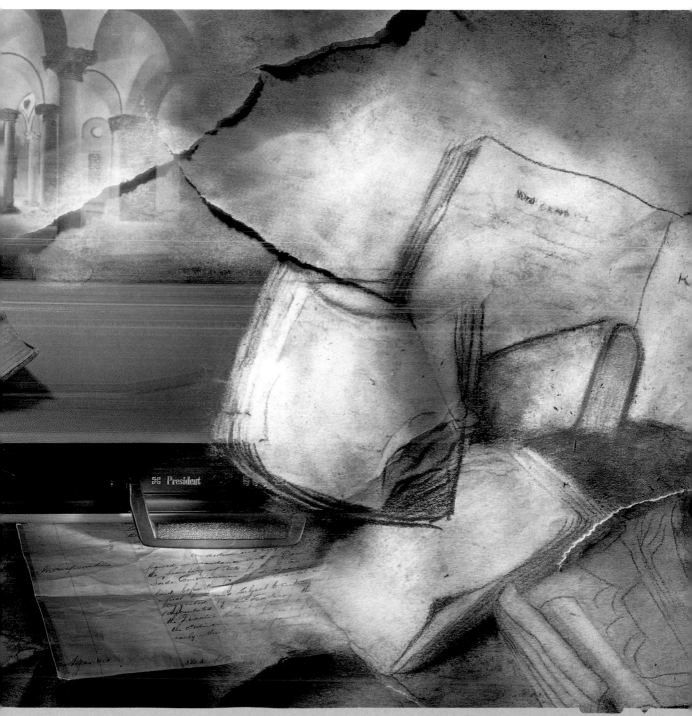

Photographer: **Robert Stedman**

Client: **Bonia Fashions**

Use: **Advertising**

Camera: **4x5 inch**

Lens: **180mm**

Film: **Kodak Ektachrome EPY ISO 100**

Exposure: **f/32**

Lighting: **Tungsten and reflectors**

Props & set: **Black paper background**

Plan View

Side View

METAL BAGS

▼

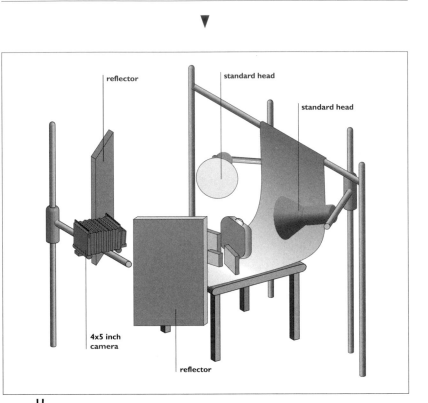

WHEN THE CLIENT WANTS TO SHOW BOTH A DETAIL — IN THIS CASE THE METAL NAMEPLATES ON THE BAGS — AND THE WHOLE PRODUCT, IT IS SOMETIMES VERY DIFFICULT TO SHOW THEM IN A SINGLE STRAIGHT SHOT. ONE ANSWER IS TO MAKE A DOUBLE EXPOSURE.

The lighting set-ups for the two shots are substantially similar, except that for the close-up, one of the lights was switched off. Two back lights, one either side of the subject and at about 45 degrees to the camera/subject axis, provided the keys: you can see how the shadows fall. Large reflectors on either side of the camera provided the fill; with the reflective material of the bags, this was very effective.

For the first shot, a black card masked the upper part of the shot. Then, with the light to camera right switched off, the second exposure was made of the single bag, which was held on a clamp; again, a black card masked the lower part of the shot, "just in case". A Polaroid test facility is invaluable when you are setting up a shot like this.

Photographer's comment:

Tough shot! The client wanted to show the special metal nameplate on the bags. We did a double exposure in camera.

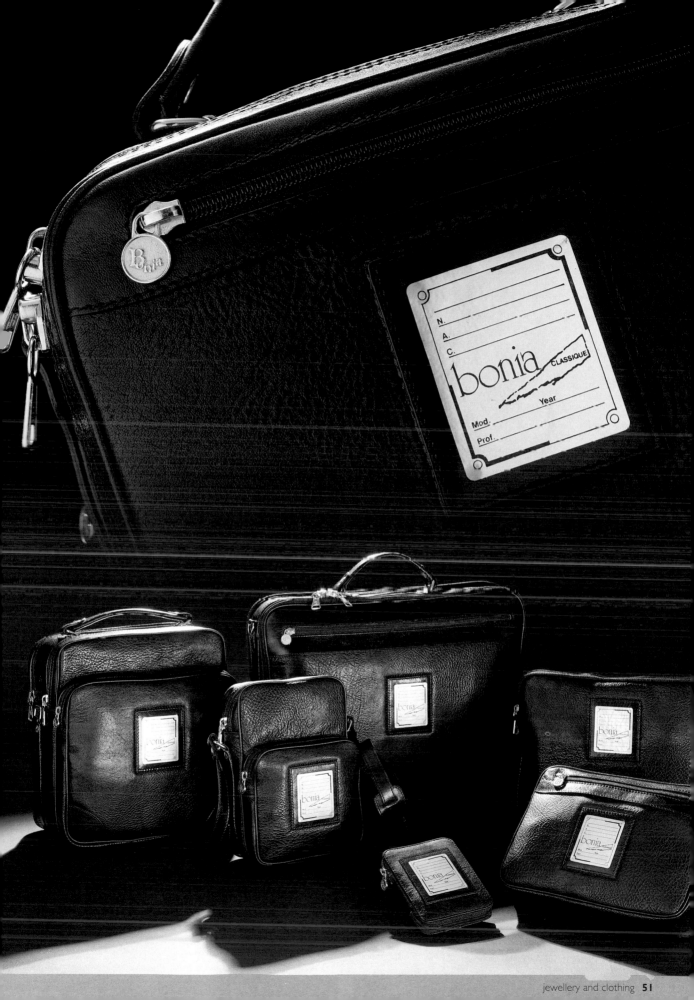

Photographer: **Robert Stedman**

Client: **Bonia Fashions**

Use: **Advertising**

Camera: **4x5 inch**

Lens: **180mm**

Film: **Kodak Ektachrome EPY ISO 64**

Exposure: **f/22: shutter speed not recorded.**

Lighting: **Tungsten: 3 heads.**

Props & set: **Lake is made from blue movie gel on styro base. Mountains are black card which is torn into shape. Moon is cake plate.**

Plan View

Side View

REPTILE BAGS

▼

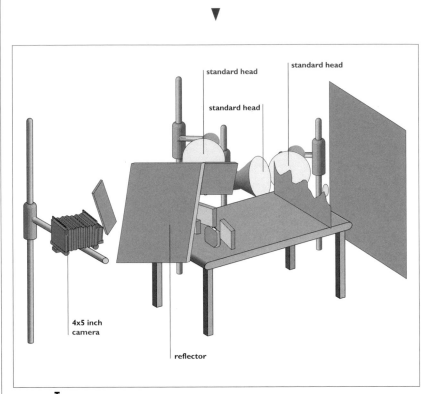

standard head

standard head

standard head

4x5 inch camera

reflector

THREE LIGHTS AND TWO REFLECTORS CREATE A MEMORABLE IMAGE. IN FACT, THE PRODUCTS THEMSELVES — THE BAGS — ARE REMARKABLY SIMPLY LIT; IT IS THE INGENUITY OF THE SET, AND THE WAY IN WHICH IT IS LIT, WHICH CREATE THE IMPACT OF THE SHOT.

The key light is to camera left and slightly behind the subject, and is bounced back onto the subject by a large styrofoam reflector to camera right; this both fills the shadows and is itself reflected in the polished leather. A smaller reflector to camera left fulfils a similar function.

The two remaining lights are concerned principally with the background. One lights the background flat and the "moon" at the back of the set, and the other casts the shadows of the "mountains" and provides the reflections in the "lake" — all of which are of course, a part of the set.

Because the entire set is back lit, the overall effect is of the leather goods on a mysterious shore; perhaps in some strange country, or perhaps in another world entirely.

Photographer's comment:

The client literally wanted the bags to look out of this world. It was fun to create the lake from movie gel and the mountains from card. The moon is actually a cake plate.

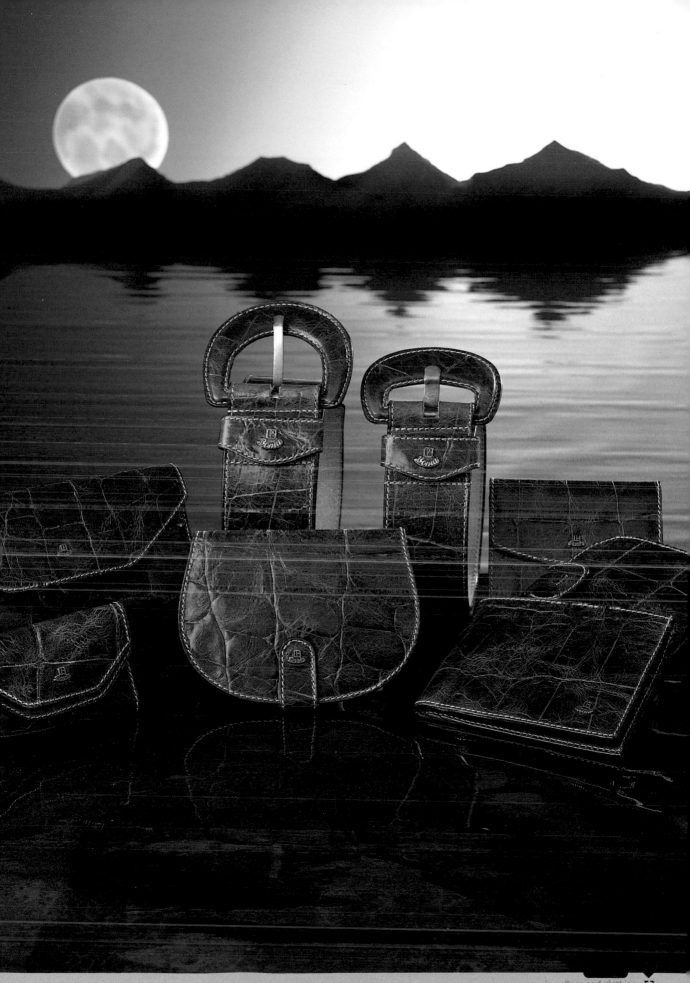

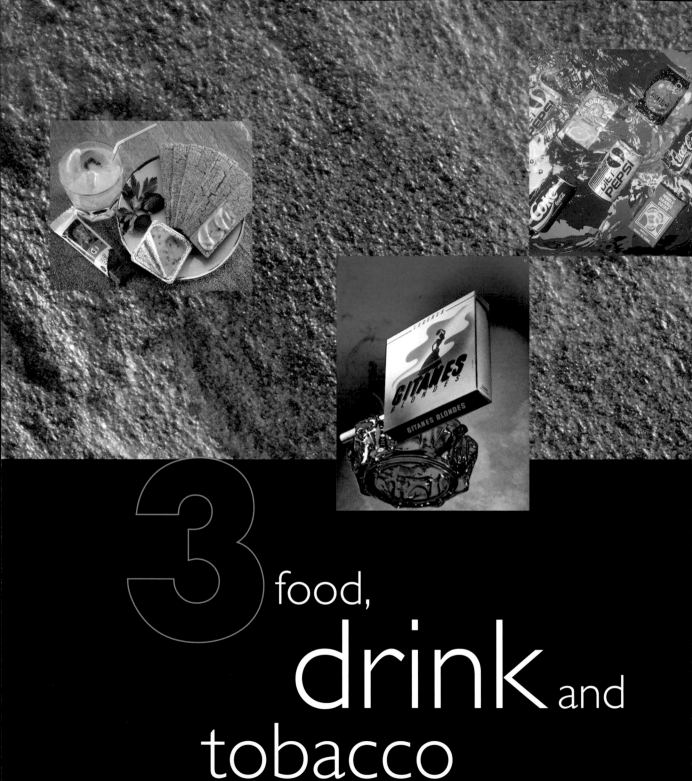

3 food, drink and tobacco

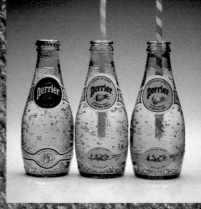

Much of the food that is advertised is not exactly a part of mankind's staple diet: bread, potatoes and rice form an extremely small sector compared with snack foods, soft drinks and prepared meals. Only rarely, for that matter, is the product allowed to speak for itself. Often, the picture builds on a series of symbols which are a semioticist's delight: Jacques Derrida and Umberto Eco have built whole theses around the difference between what is promised, what exists, and what we hope for.

This may seem an improbably high-flown philosophical level on which to consider product shots of food and non-alcoholic drinks, and it is true that for the most part, "what looks right, is right". This is the way that the vast majority of photographers operate, taking the art director's brief and translating it non-verbally into an attractive image. Even so, a little philosophizing may make it easier to shoot some types of pictures: as one successful pack shot photographer said, "Often, there's not much you can do with the product; it's just boring. So you light the background interestingly, and then you put the product in front of that."

Finally, there are increasing legal restrictions on advertising tobacco, so the problem today is often to create an evocative mood without (for example) linking cigarettes with healthy outdoor pursuits.

SHAPERS RANGE

▼

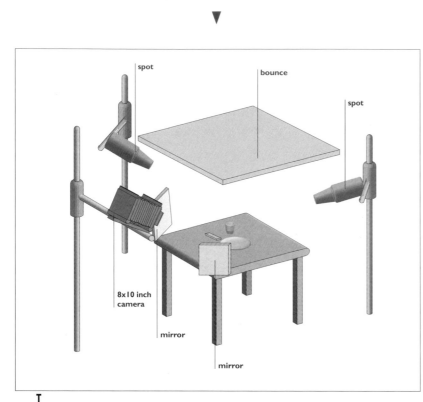

Photographer: **Terry Ryan**

Assistant: **Nicholas Hawke**

Client: **Boots**

Use: **Window display poster (120x120cm)**

Art director: **David Ross, The Boots Company**

Camera: **8x10 inch**

Lens: **360mm**

Film: **Kodak Ektachrome EPP 100, push 1/3 stop**

Exposure: **f/45**

Lighting: **Electronic flash: 2 heads**

Props & set: **Stone slab background**

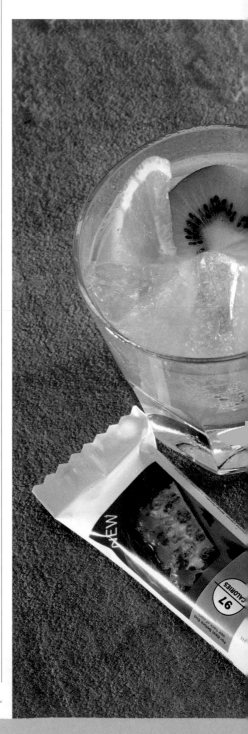

TEXTURE IS THE WATCHWORD IN THIS STUDY OF FOODS FROM THE BOOTS SLIMMERS' RANGE, WHICH IS ONE OF THE REASONS WHY TERRY RYAN USED AN 8x10 INCH CAMERA; AND IT IS ALSO WHY THE LIGHT IS VERY GLANCING.

In fact, the light comes from three sides at once, with a very tight lighting ratio: the shadows (to the left) are barely visible. The key is a 5000ws spot from camera right, back lighting the subject, but fill is provided by another 5000ws spot above a mirror to camera left and providing front light. The fill light is fitted with a bastard amber filter to warm the light, as can be seen in the lower highlights on the crispbread. An additional mirror to camera right reduces the shadow on the right-hand side of the plate, while a bounce above the subject provides still more fill and gives even illumination on the foil top to the spread box.

Photographer's comment:

The purpose of the shot was to show part of a range of low calorie products in the Boots Shapers range, for a 4'x4' (120cm square) semi-cutout window display.

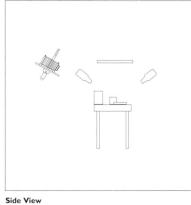

Side View

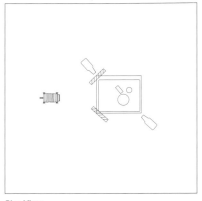

Plan View

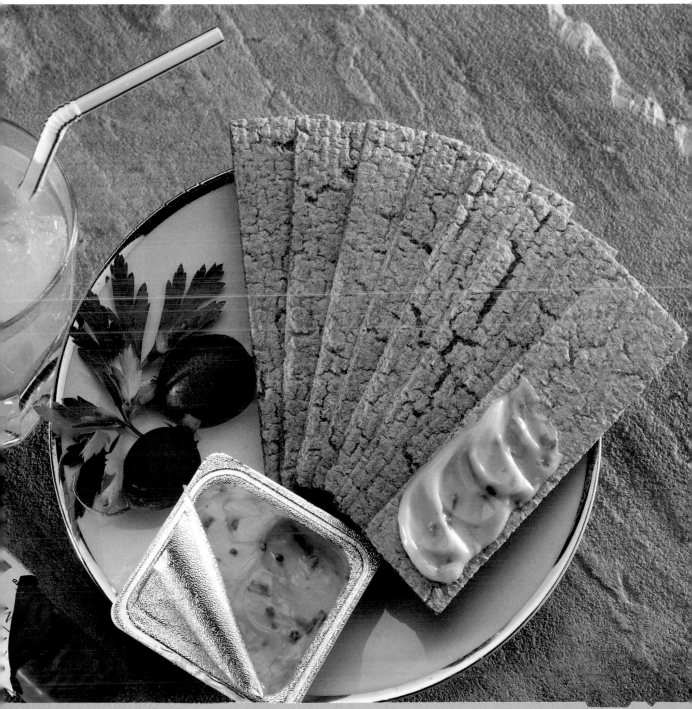

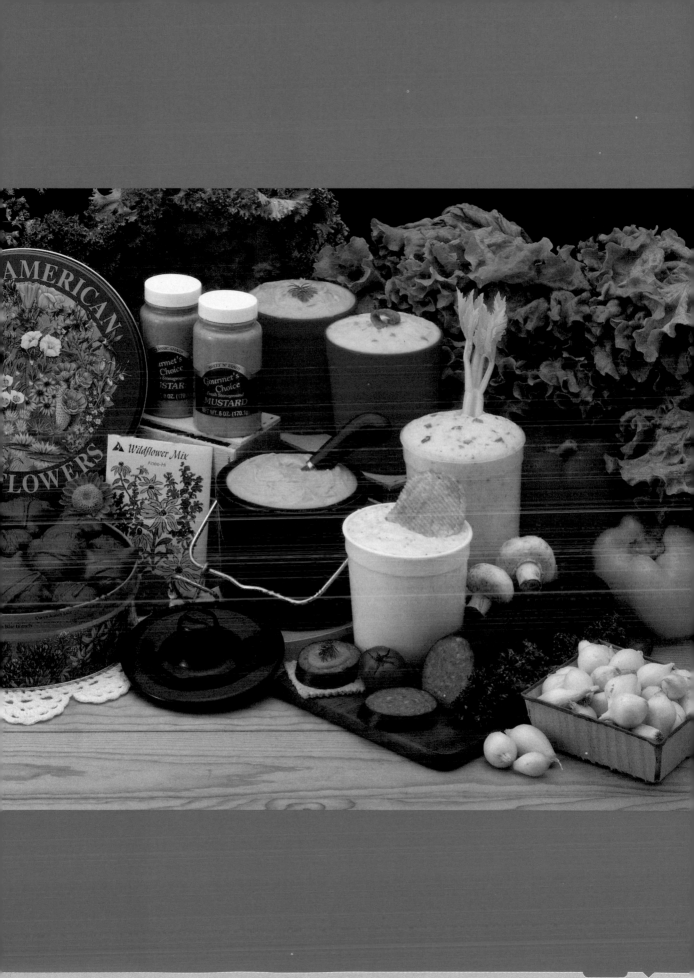

Photographer: **Jim DiVitale**

Client: **Amtrec, Inc**

Use: **Brochure**

Food stylist: **Jeff Hall, Amtrec**

Prop stylist: **Sandy DiVitale**

Art director: **Jeff Hall**

Camera: **8x10 inch**

Lens: **360mm**

Film: **Kodak Ektachrome 64**

Exposure: **f/32**

Lighting: **Electronic flash: 2 heads, both soft boxes.**

Props & set: **Doilies, dishes, crates, fruit basket, antique milk jug, vegetables, pine wooden slats.**

Plan View

Side View

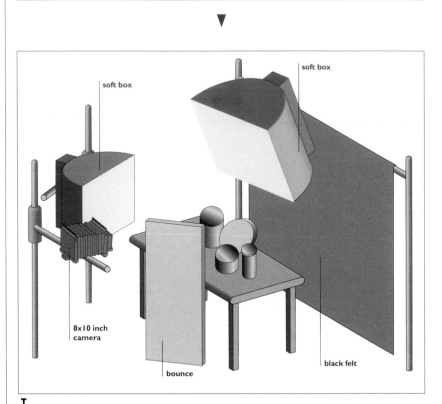

soft box

soft box

8x10 inch camera

bounce

black felt

THERE IS A HAPPY MEDIUM IN PRODUCT SHOTS. COME IN TOO CLOSE, AND ANY FLAWS IN THE SUBJECT ARE SHOWN UP MERCILESSLY. SHOOT TOO COMPLEX A SUBJECT, AND UNLESS YOU DO IT RIGHT, THE SHOT BECOMES "BITTY" AND IT IS HARD TO HOLD DETAIL WHERE IT IS NEEDED.

Jim DiVitale of course did it right, despite the wildly disparate design elements and the range of tones from milk white to very dark indeed, plus the occasional piece of bright metal and painted "tin".

A big (120x180cm) soft box above the subject provides most of the light, while another good-sized soft box (90x120cm) to camera left adds some modelling and highlights; a large (120x120cm) sheet of foam-core board to camera right reflects some fill. Cropping the 8x10inch image to a very long, thin panoramic format approximately 10x25cm encourages the eye to search through the image, instead of attempting to take it all in at a glance; it is a picture which can be studied. This is one reason why some people prefer the 6x17cm format (similar in proportions to this) to 6x12cm.

Photographer's comment:

The challenge of the shot was to carefully balance the dark sausage, light cheeses, and metallic labels, holding detail in all. This image won a Kodak Gallery Award for Commercial Photography in 1991.

Photographer: **Mark Wragg**

Assistant: **Martin Ramsey**

Client: **Superdrug**

Use: **In-store advertising**

Art director: **Rachel Williams**

Camera: **4x5 inch**

Lens: **150mm**

Film: **Kodak Ektachrome EEP 100**

Exposure: **f/22**

Lighting: **Electronic flash: 2 heads, both soft boxes.**

Props & set: **Water tank**

SOFT DRINKS

▼

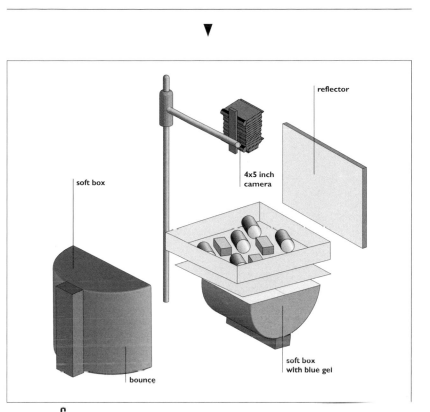

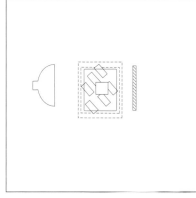

Plan View

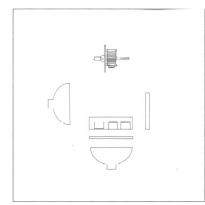

Side View

Surprisingly enough, what you see is what you get. This is an absolutely straight shot of a variety of soft drinks in a tank-full of water, which was agitated by three people standing around the edges busily making waves.

A small soft box to camera left provides the key for the cans, and a large white reflector to camera right provides the fill. The water tank is lit from below, through several pieces of blue gel of different colours. That is all there is to it.

Except, of course, as anyone knows who has tried this sort of thing, there is always more to it than this. The soft drinks have to be secured, or they start rolling and moving around; they often have to be re-arranged, to get the colours and shapes right; and you always have to be very careful when you mix high-voltage flash equipment and water. Because the pattern of the waves is unpredictable and unrepeatable, you also need to shoot quite a lot of pictures to be sure of getting one that works.

Photographer's comment:

An eye-catching graphic shot, showing the coolness of the drinks.

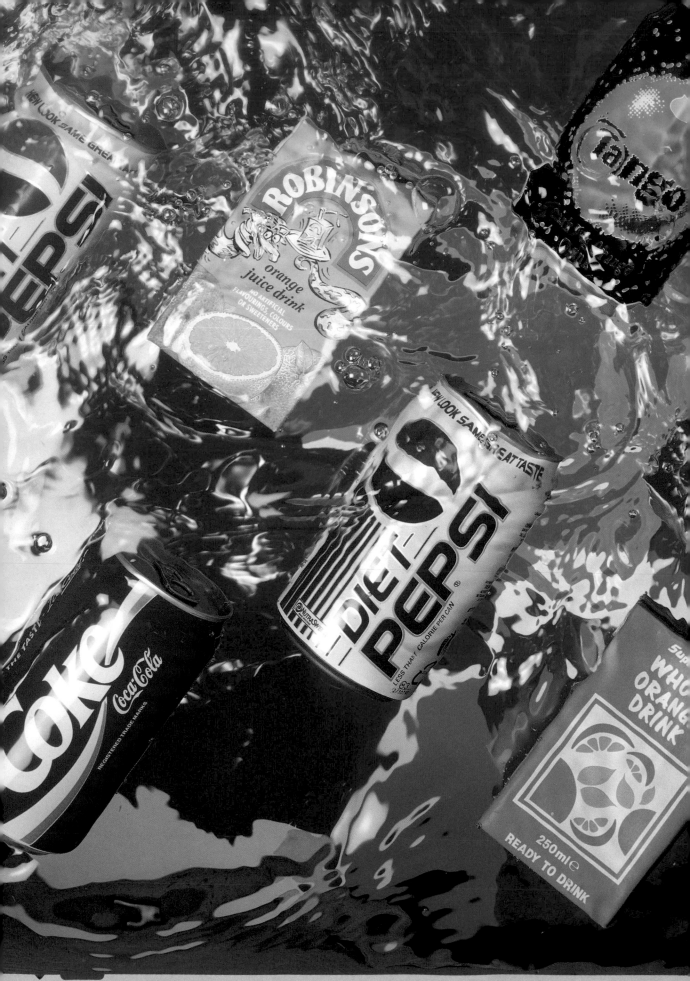

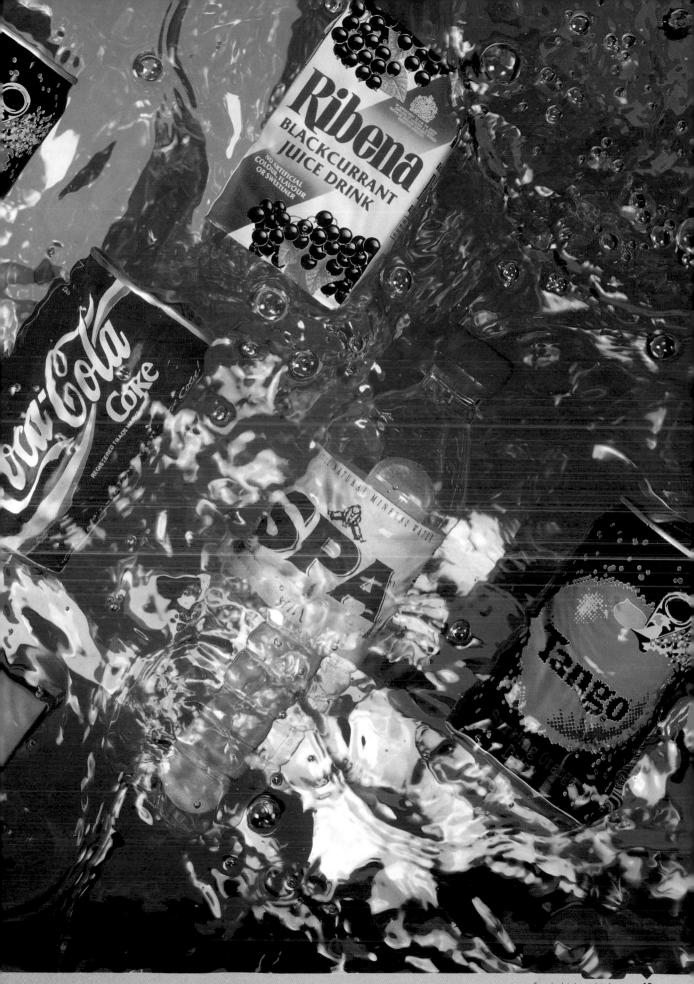

PAN ARTESANO

▼

Photographer: **Albert Marli**

Client: **Fet D'Ara**

Use: **Advertising and point-of-sale poster**

Art director: **Isabel Tiana**

Agency: **Creativos de Publicidad SA**

Camera: **4x5 inch**

Lens: **360mm**

Film: **Kodak Ektachrome 100 Plus**

Exposure: **f/45**

Lighting: **Electronic flash: 2 heads**

Props & set: **Baskets; heads of wheat; linen napkins. Rustic wood table, painted background**

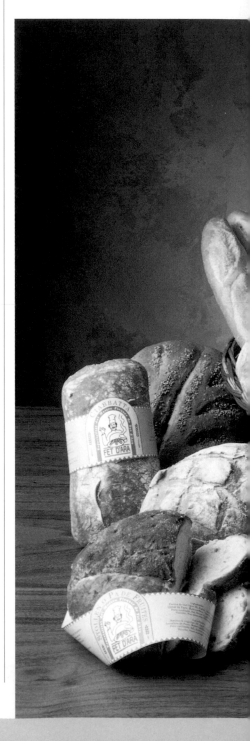

As the photographer puts it, "In the current climate of ecological awareness, the aim was to show how everything in bread is totally natural. The photograph is composed around those natural ingredients."

The lighting is straightforward. A large soft box to camera left provides the sole illumination, with a large bounce to camera right which fills the shadows while still retaining the roundness of the loaves thanks to the chiaroscuro created by a soft but directional light. Because there are no real highlights on bread, there is no need to use effects lights of any kind. The background is illuminated with a single standard head, covered with a yellow filter to create a warm, sunny mood.

It is also worth adding that 4x5 inch is the smallest film size one could conveniently use for a shot like this, in order to capture the wide variety of textures: the powdery flour, crisp crust, delicate crumb, and coarse-woven linen.

Photographer's comment:

The aim was to glorify the value of traditional artisanal bread-making skills.

Side View

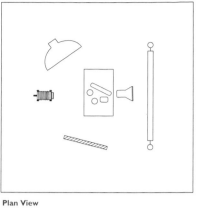

Plan View

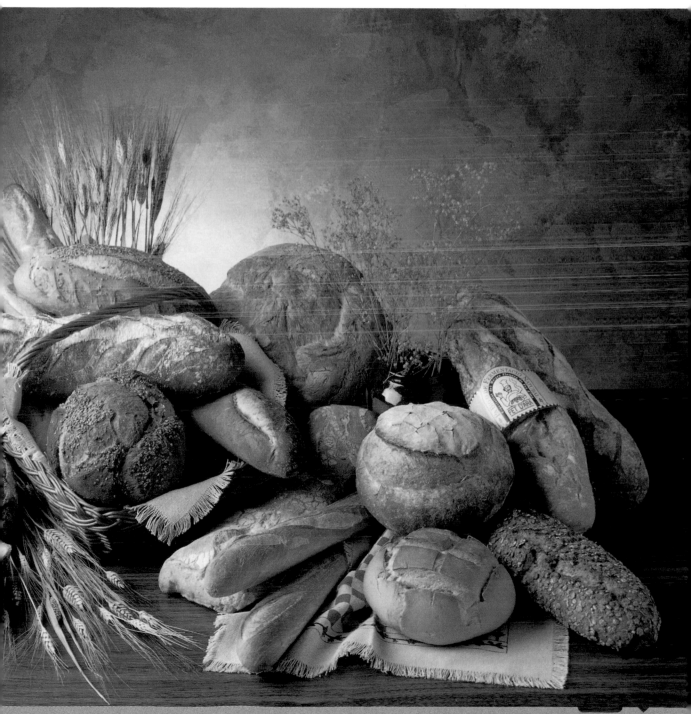

Photographer: **Jaime Malé**

Client: **Marcilla**

Art director: **Manuel Padilla**

Camera: **5x7 inch**

Lens: **360mm with partial soft filter**

Film: **Kodak Ektachrome 64**

Exposure: **f/45**

Lighting: **Electronic flash (1 head) and light brush**

Props & set: **Painted background**

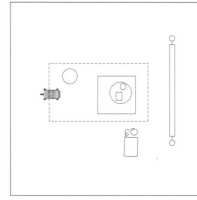

Plan View

Side View

C A F E

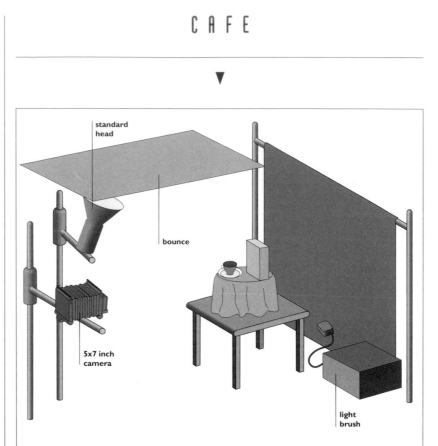

standard head

bounce

5x7 inch camera

light brush

THIS IS ONE OF ONLY A FEW PICTURES IN THE BOOK WHICH WERE LIT ENTIRELY OR ALMOST ENTIRELY WITH A LIGHT BRUSH. A STANDARD REFLECTOR HEAD BOUNCED FROM AN OVERHEAD REFLECTOR PROVIDED THE OVERALL OR KEY LIGHT, WHILE THE LIGHT BRUSH DID ALL THE REST.

The "bar" of light at the back directs attention both to the steaming mugs (the "steam" was added as a double exposure) and to the pack, which is at once spotlit and yet isolated from the background; the light brush enabled Jaime Malé to emphasize the new brand name (Gran Expresso) without the concomitant awkward spill which might have resulted from the use of a more traditional form of lighting.

Further strokes of the light brush emphasized the drape of the tablecloth, and added to the warmth and intimacy of the picture. This shot has a very considerable impact, which results in large measure from skilled use of the light brush, assisted by the use of the warm, brown tones which we associate with coffee.

Photographer's comment:

The lighting creates an atmosphere of intimacy in the picture as a whole, while at the same time highlighting the name of the new brand of coffee from Marcilla.

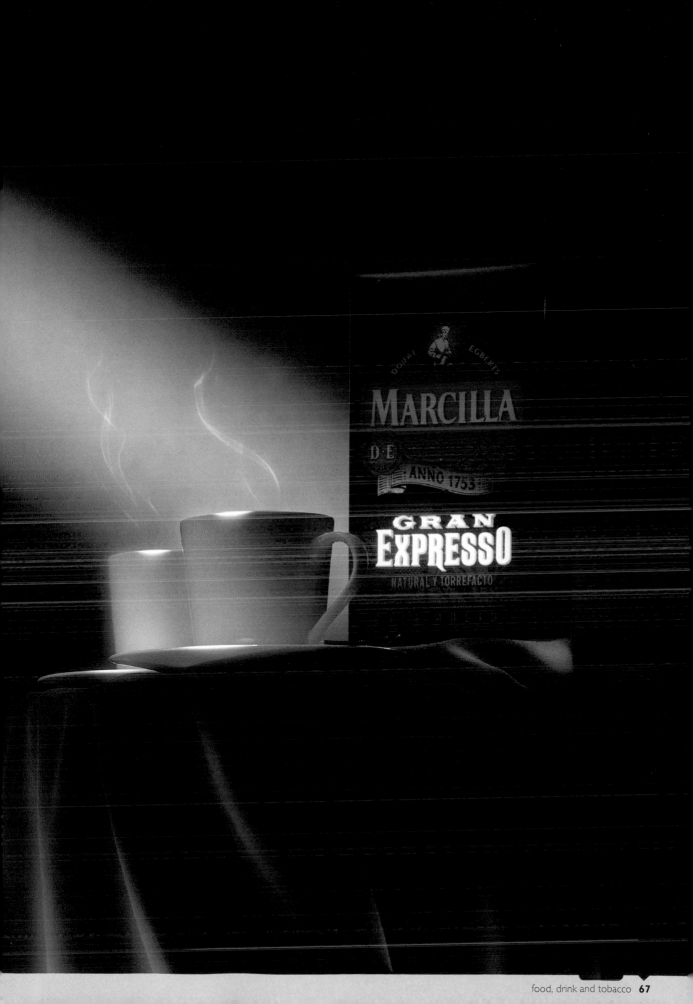

PERRIER

▼

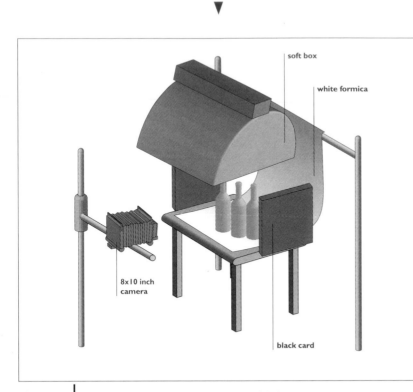

- soft box
- white formica
- 8x10 inch camera
- black card

Lᴛᴋᴇ ᴛʜᴇ Mᴀʀᴋ Wʀᴀɢɢ sʜᴏᴛ ᴏɴ ᴘᴀɢᴇs 62/64, ᴛʜɪs ɪs ᴀɴ ᴇxᴀᴍᴘʟᴇ ᴏғ "ᴡʜᴀᴛ ʏᴏᴜ sᴇᴇ ɪs ᴡʜᴀᴛ ʏᴏᴜ ɢᴇᴛ". Hᴏᴡᴇᴠᴇʀ, ᴛʜᴇ sɪᴍᴘʟᴇ sᴏғᴛ ʙᴏx ʟɪɢʜᴛɪɴɢ ɪs sɪɢɴɪғɪᴄᴀɴᴛʟʏ ᴍᴏᴅɪғɪᴇᴅ ʙʏ ᴛʜᴇ ᴜsᴇ ᴏғ ʙʟᴀᴄᴋ ᴄᴀʀᴅs ᴏɴ ᴇɪᴛʜᴇʀ sɪᴅᴇ ᴏғ ᴛʜᴇ ʙᴏᴛᴛʟᴇs ᴛᴏ ᴄʀᴇᴀᴛᴇ sᴛʀᴏɴɢ, ɢʀᴀᴘʜɪᴄ sʜᴀᴘᴇs.

A soft box directly over the bottles is the only source of light, and it can be seen most clearly in the bubbles. A white Formica (plastic laminate) background provides reflection and bounce. This is perhaps one of the best illustrations in the book of the technique of using "black bounce" to provide edge delineation.

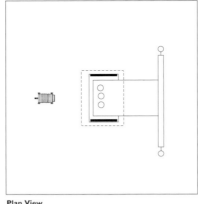

Plan View

Photographer: **Andrew Whittuck** Client: **Perrier/Leo Burnett** Use: **Advertising** Art director: **David Owen** Camera: **8x10 inch** Lens: **360mm** Film: **Kodak Ektachrome ISO 64 Daylight** Exposure: **f/45-1/3 (f/50)** Lighting: **Electronic flash: 60x90cm soft box.** Props & set: **3 Perrier bottles with straws on white Formica background**

Photographer's comment:

Simple soft lighting, a classic still life pack shot.

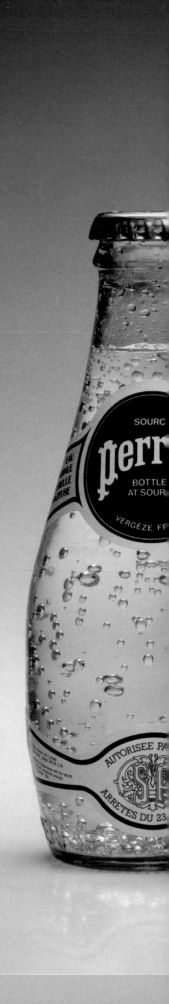

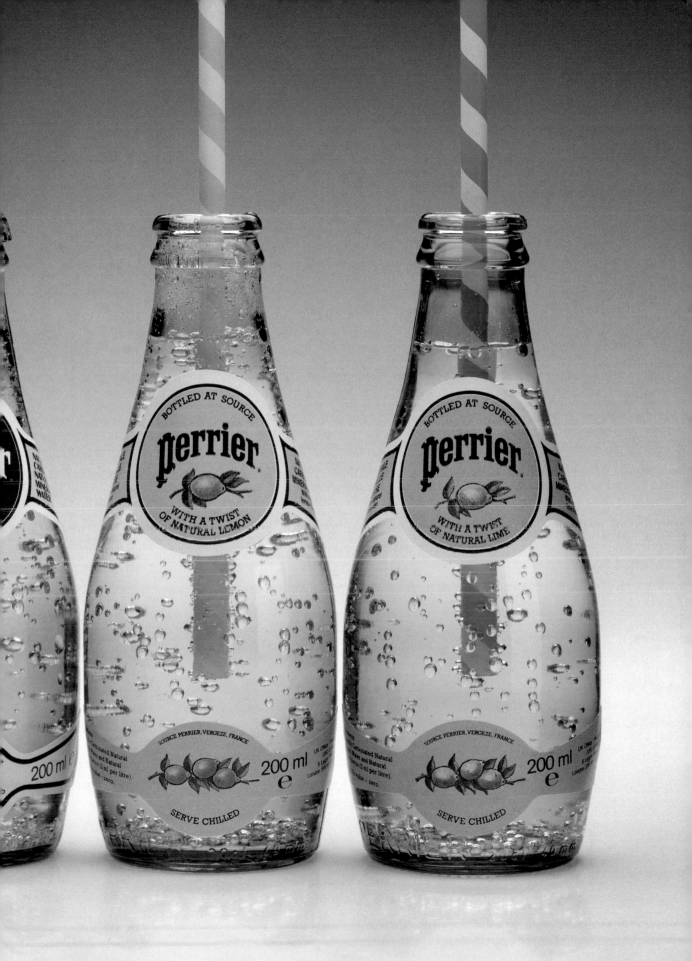

Photographer: **Terry Tsui**

Client: **A & T Advertising**

Use: **Editorial**

Art director: **Tony So**

Camera: **4x5 inch**

Lens: **240mm**

Film: **Step 1/Kodak Ektachrome 100 Plus 6105**

Step 2/1Kodak Ektachrome duplicating 6121

Exposure: **f/32-1/2 (f/39)**

Lighting: **Step 1/Electronic flash: 2 heads plus 3 mirrors.**

Props & set: **Step 1/White Paper**

Step 2/blue filter

Plan View

Side View

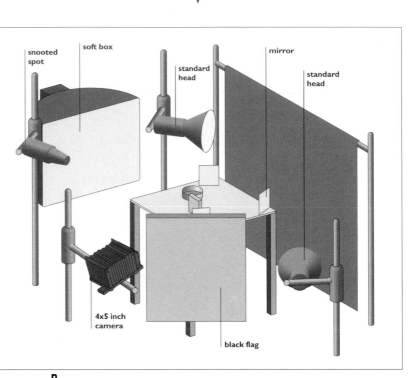

Duplicating a relatively straight shot on a transilluminated diffuser made of tracing paper allowed Terry Tsui to add further colour — the characteristic blue of French cigarettes, contrasting with subtle pinks — with the aid of masks and gels in a sequence of multiple exposures.

The camera was shooting upwards through the clear glass table on which rested the Gitanes packet, the ashtray and the cigarette. A 35x60cm soft box provided the key light, while a second head to camera left with a snoot and a honeycomb highlighted the flowers and provided some modelling in the cigarette, as well as creating highlights on the glass of the ashtray. Three mirrors highlighted the smoke and the cigarette, while a black flag to camera right increased the edge differentiation of both the ashtray and the cigarette packet.

The original shot was then duplicated while taped to a piece of glass over a diffuser transilluminated with two tungsten lights, and by cutting gels and masks to shape, the photographer was able to add the rich blue tints.

Photographer's comment:

The masking technique is most important in this picture. The blue colour is what really emphasizes the image of the cigarette.

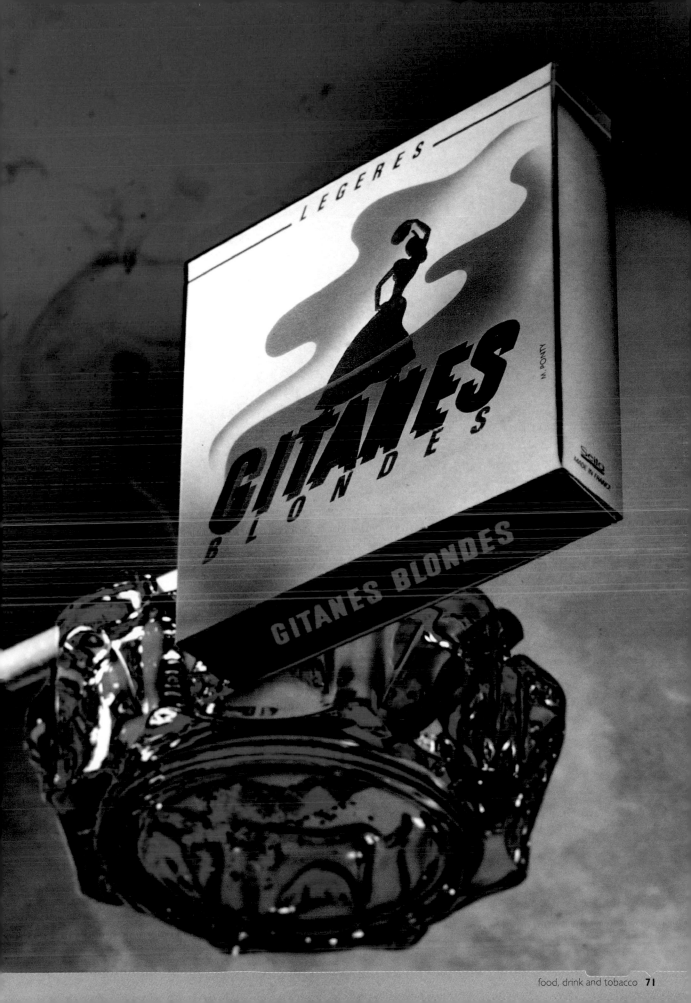

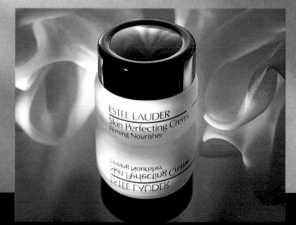

Like alcohol, cosmetics lend themselves to "pure" advertising. That is to say, because they are not essential to the maintenance of life or even bodily comfort, it is not a question of getting a customer to switch brands, from some other product which he or she would have to buy anyway. Rather, it is a matter of creating demand where little or none exists – or where, at best, there is a vague and generalized desire to look and smell good which an earlier generation might have met with plain soap and water.

The main difference between cosmetics advertising and alcohol advertising is that the range of techniques and expressions open to the photographer is significantly greater when it comes to cosmetics. Not only are the clients more adventurous: so are the people to whom they are selling.

There is no immediately apparent reason why this should be so, except perhaps that with cosmetics there is much less of a need to bow to tradition; only a few cosmetics manufacturers deliberately try to re-create Victorian and Edwardian

SKIN PERFECTING CREAM

Photographer: **Pauline Mary Stevens**

Client: **Estée Lauder**

Camera: **4x5 inch**

Lens: **210mm**

Film: **Kodak Ektachrome 64 Tungsten**

Exposure: **Not recorded**

Lighting: **Tungsten: 2 heads plus reflector cards.**

Props & set: **White silk; mirror background.**

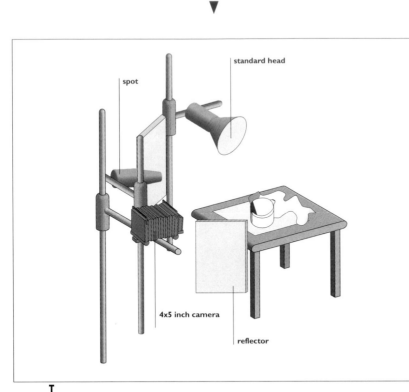

THE SECRET OF THIS PICTURE IS THE WHITE SILK, WHICH REFLECTS AND DIFFUSES THE LIGHT SO THAT IT IS DIFFICULT TO DEFINE EITHER THE KEY OR THE FILL. THE BACKGROUND IS A SILVERED GLASS MIRROR; IF YOU LOOK CAREFULLY, YOU CAN JUST SEE THE SECONDARY REFLECTIONS IN THE GLASS.

Both lights are placed to camera left, one beside the subject at 90 degrees to the camera/subject axis and one just to the left of the camera. The small light to the left of the camera is a Dedolite miniature spot which greatly reduces the effect of the reflection in the lid. The roundness or volume of the cap is created by two reflector cards, symmetrically placed at either side of the camera, which provide highlights as well as fill.

In a picture like this, you may need to re-arrange the silk several times in order to get an attractive drape (picking it up and dropping it often works very well). A moderately wide aperture, probably about f/11 or f/16, helps concentrate attention on the writing on the label while allowing most of the silk to go soft.

Photographer's comment:

What is nice in this shot is that both the cream and the silk together give a very clean feeling, as well as an attractive reflection.

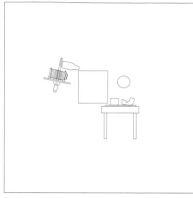

Side View

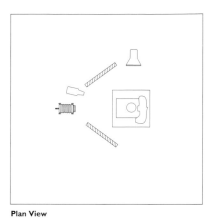

Plan View

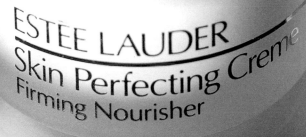

ESTĒE LAUDER
Skin Perfecting Creme
Firming Nourisher

Photographer: **Franco Donaggio**

Client: **Christian Dior**

Use: **Pitch for advertising campaign**

Camera: **8x10 inch**

Lens: **300mm**

Film: **Kodak Ektachrome 64**

Exposure: **f/22**

Lighting: **Electronic flash: 2 heads**

Props & set: **Hand-drawn pattern for background**

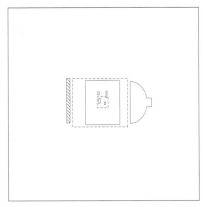

Plan View

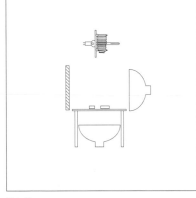

Side View



D I O R

▼

FRANCO DONAGIO OFTEN USES GRAPHIC ARTWORK AS A COMPLEMENT TO HIS SUBJECT MATTER, TO VERY GOOD EFFECT AS CAN BE SEEN HERE; BUT THE LIGHTING ITSELF IS COMPARATIVELY SIMPLE, JUST TWO SOFT BOXES AND A REFLECTOR.

The background of translucent acrylic sheeting is transilluminated by one soft box with a magenta gel, while another soft box to one side balances the illumination on the lipstick itself, giving good highlights in the gilt stripes on the cap and deep, rich colours elsewhere. A reflector opposite the second soft box ensures a soft, even light, but with enough highlights and shadows to create modelling in the metallic cylinder at the base of the lipstick itself. The camera is pointing straight down onto the transilluminated background.

The memorable symmetry of the image is achieved by taking two exposures, laying one atop the other – one right-way-round, the other "flopped" – and then shooting the sandwiched images to create a single picture.

Photographer's comment:

The important thing in this picture is the personal nature of the vision.

DRAKKAR NOIR

▼

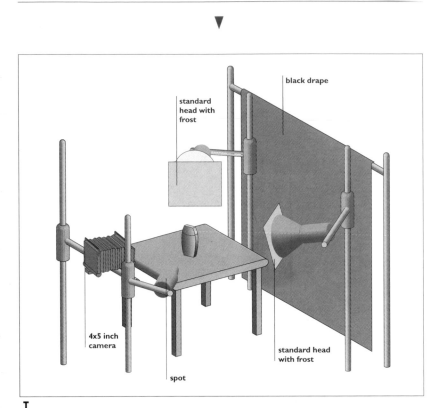

standard head with frost

black drape

standard head with frost

4x5 inch camera

spot

THIS IS MORE EASILY ACHIEVED THAN YOU MIGHT THINK, AS THE SUBJECT WAS NOT MOVED AT ALL: INSTEAD, THE CROSS MOVEMENTS OF THE CAMERA WERE USED TO CREATE THE MULTIPLE EXPOSURE. LIKE SO MANY IMAGES IN THIS BOOK, IT IS EASY WHEN YOU KNOW HOW.

Photographer: **Salvio Parisi**

Use: **Personal work**

Camera: **4x5 inch camera with 6x7cm back**

Lens: **150mm**

Film: **Fuji RTP 64**

Exposure: **f/8-1/2 (f/10.5) quintuple exposure**

Lighting: **Tungsten; 3 heads.**

Props & set: **Black velvet background**

The bottle of Drakkar Noir was sitting on black velvet, with a black velvet background. Two back lights provided the key; both were at about 45 degrees to the camera/subject axis, one on either side.

Only the right-hand light was used for the first three exposures. With a heavy blue filter over the camera lens, the extreme right-hand image was exposed. The back cross was then moved slightly, moving the image to the left, and a green filter was substituted for the blue; this is the second exposure. For the third exposure, a red filter was used and the cross movement again moved the image.

The other back light was now switched on, and the camera cross movement utilized for the last time, to give the fourth exposure with both sides illuminated. Finally, a very precisely directed spot illuminated the "Drakkar Noir" name.

Photographer's comment:

Five exposures: three filtered ones (blue, green, red) with horizontal shift and one with both sides back lit and one with a small spotlight on "Drakkar".

Side View

Plan View

DRAKKAR
NOIR

Photographer: **Peter Laqua**

Client: **FA Heinz Glas**

Use: **Brochure**

Camera: **9x12 cm**

Lens: **240mm**

Film: **Kodak**

Exposure: **1/60 second at f/32-1/3 (f/36)**

Lighting: **Electronic flash: 2 heads.**
1 strip, 1 spot.

Props & set: **Black paper, plastic foil,**
Plexiglas sheet.

Plan View

Side View

▼

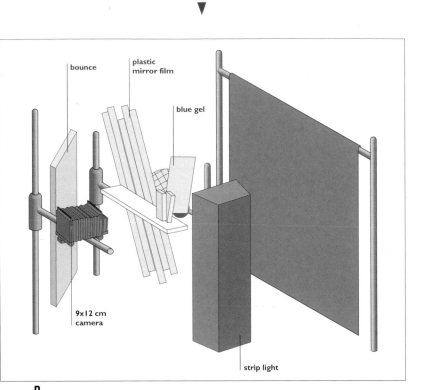

PRODUCT RECOGNITION IS OFTEN AN IMPORTANT FACTOR IN PRODUCT SHOTS; THE MANUFACTURER WANTS HIS PRODUCT TO BE INSTANTLY RECOGNIZABLE AMONGST A WIDE VARIETY OF SUPERFICIALLY SIMILAR PRODUCTS. IN THIS CASE, THE SHAPE OF THE BOTTLE AND THE "HIGH-TECH" IMAGE WERE PARAMOUNT.

The two bottles are standing on a sheet of Perspex and are lit by a strip light from the right; this clearly emphasizes the distinctive vertical lines on the side of both bottles. The blue background stripe echoes the shape of the bottles; it is made of plastic film, bunched together and secured at either end. Lighting for this comes from a honeycomb spot half covered with a blue gel; only half covering the light source with the gel means that there is a mixture of blue and white light on the plastic, which is deliberately left slightly out of focus. The background itself is of black paper, some way behind the whole set and unlit, so that the image stands out against a jet-black background.

Photographer's comment:

The shape of the bottles was the important thing; we wanted them to be immediately recognizable. The background echoed that shape.

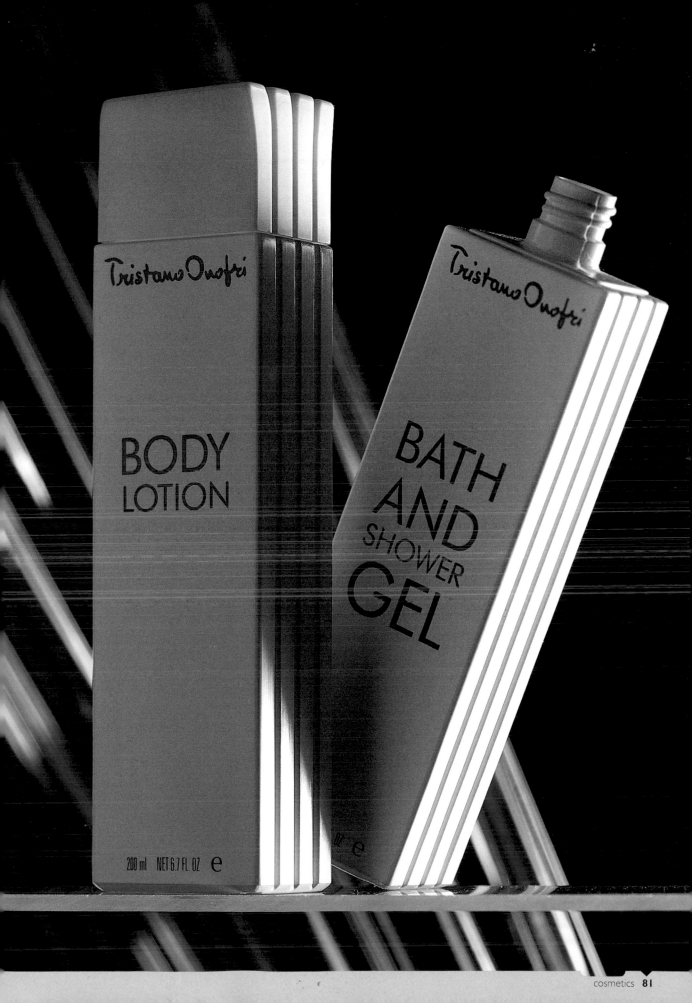

Photographer: **Franco Donaggio**

Client: **Lancaster S.p.A. Agenzia SOLARIS**

Use: **Press advertising**

Camera: **4x5 inch**

Lens: **300mm**

Film: **Kodak Ektachrome 64**

Exposure: **f/22 – double exposure**

Lighting: **Electronic flash: 5 heads. First exposure with 3 soft boxes, second exposure 2 heads with standard reflectors.**

Props & set: **The background is a graphic image by the photographer**

Plan View

Side View

▼

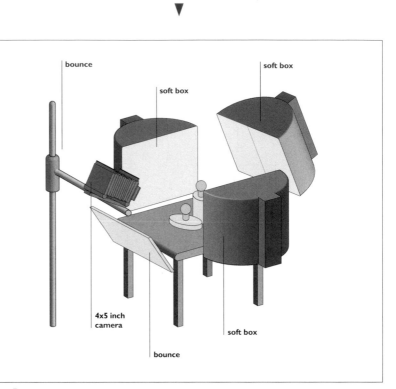

bounce

soft box

soft box

4x5 inch camera

soft box

bounce

THIS PICTURE DEPENDS ON THE USE OF MASKS IN FRONT OF THE CAMERA LENS. WITH ONE MASK IN PLACE, THE SUBJECT WAS PHOTOGRAPHED ON THE FLOWERED GROUND. A SECOND MASK, THE EXACT OPPOSITE OF THE FIRST, WAS THEN USED TO MASK THE CAMERA FOR THE SECOND EXPOSURE.

In this way, only the subject was recorded with the first exposure — everything else was masked out — and only the background was recorded with the second exposure, with a "hole" where the subject had already been recorded on the film.

For the first exposure, three soft boxes were used. The key is to camera left; another, above and slightly behind the subject, was set a stop or so down; and the third, to camera right, was weaker again. A reflector under the camera provided extra fill. You can see the reflections of all these in the bottle caps.

The second exposure was a straightforward copy shot, with the graphic image lit by two heads at 45 degrees. The whole thing depends on very precise mask cutting and registration on the ground glass.

Photographer's comment:

I was given the freedom to do whatever I liked, as long as it had a "Christmassy" image (which was when the campaign ran) with an exotic, Oriental mood.

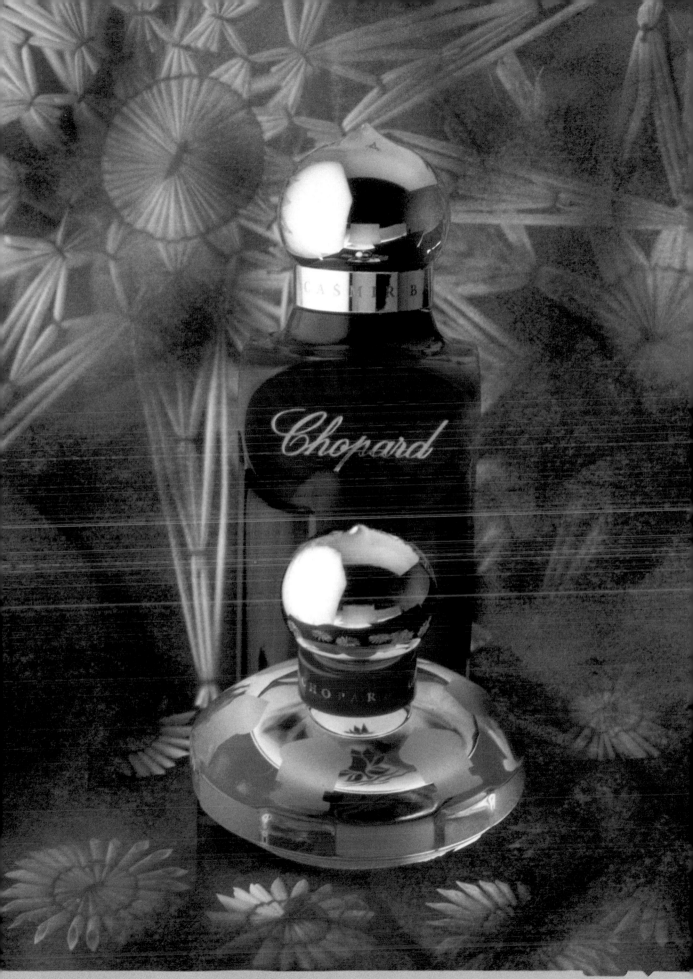

Photographer: **Salvio Parisi**

Client: *Hair & Beauty* **Magazine**

Use: **Editorial**

Model: **Chicca Fusco**

Make-Up: **Francesco Riva**

Camera: **4x5 inch camera with 6x7cm back**

Lens: **210mm**

Film: **Fuji RDP 100**

Exposure: **f/22**

Lighting: **Electronic flash: 4 heads. 1 soft box, 1 spot, 2 reflector heads.**

Props & set: **Model; white seamless background.**

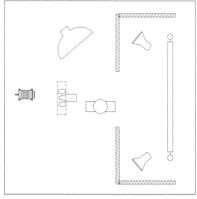

Plan View

Side View

GIRL AND PERFUME

▼

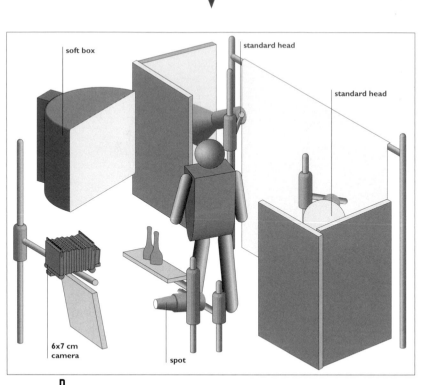

BOUNDARIES ARE OFTEN HARD TO DEFINE IN PHOTOGRAPHY; A MODEL MUST BE THE ULTIMATE ACCESSORY IN A PRODUCT SHOT, AND INDEED MANY WOULD ARGUE THAT THIS IS NOT A PRODUCT SHOT AT ALL. BUT IF IT IS NOT A PRODUCT OR PACK SHOT, THEN WHAT IS IT?

Salvio Parisi used a 6x7cm back for additional depth of field. At a given aperture, depth of field depends solely on the image size on the film, so a smaller film size implies greater depth of field. He also used camera movements to control sharpness and depth of field.

The lighting is effectively in three layers: the perfume, the model and the background. The two perfume bottles are lit by a bounce flash, a spotlight reflected from a white card, for a narrowly defined light without awkward spill or shadows. The model is lit by a soft box to camera left but well in front of the subject, to differentiate her adequately from the background, which is lit with two standard reflector heads bounced off a pair of L-shaped reflectors.

Photographer's comment:

The point was to find the exact parallelism between the girl's body and the shape of the bottle of perfume.

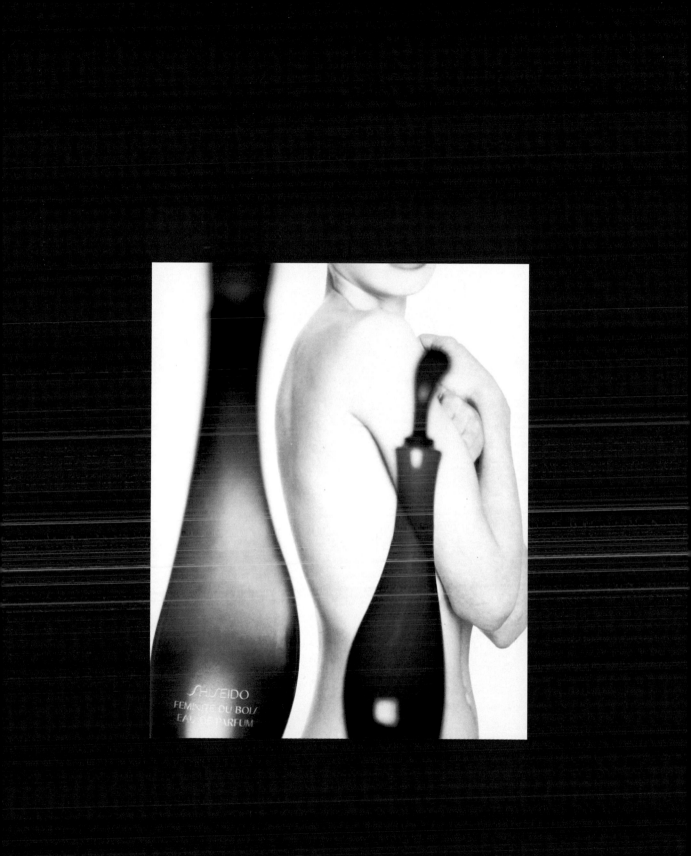

A V O N

▼

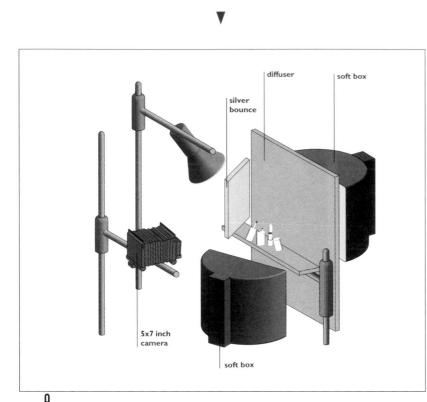

diffuser · soft box · silver bounce · 5x7 inch camera · soft box

Photographer: **Mike Galletly**

Client: **Avon Cosmetics Ltd.**

Use: **Magazine advertising**

Camera: **5x7 inch**

Lens: **360mm**

Film: **Kodak Ektachrome EPR 64**

Exposure: **f/45**

Lighting: **Electronic flash: 3 heads**

Props & set: **Glass shelf; background of tracing paper**

AT FIRST SIGHT, THIS LOOKS LIKE A SIMPLE SOFT BOX SHOT; BUT IN FACT, THE USE OF REFLECTORS AND A SMALL ADDITIONAL HEAD TO GIVE SPARKLE IS BOTH SUBTLE AND CLEVER. THERE IS ALSO CONSIDERABLE ATTENTION TO DETAIL AND TO COMPOSITION.

The glass shelf on which the products rest is in front of a screen made of tracing paper, which is transilluminated by a medium-sized soft box. A second medium-sized soft box to camera right creates the principal highlights, supplemented by a small matte silver reflector to camera left, which (as you can see from the highlights) functions as an additional light about a stop and a half down from the key. Finally, a small head directly above the subject is fitted with a 40x40cm (15inch square) reflector with a medium honeycomb. This creates the highlights on the tip of the lipstick, the top of the lipstick cap, the metal surround to the lipstick and so forth. Without this small effects light, the picture would have the same graphic strength, but it would lack sparkle.

Photographer's comment:

This was a fairly straightforward shot, but because of the final size of the image it had to be very clean, and the product had to be free of dust and imperfections.

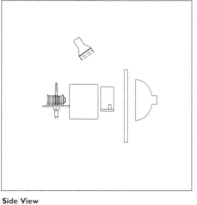

Side View

Plan View

Photographer: **Manuel Fernandez Vilar**

Client: **Joyeria Roma**

Use: **Magazine advertising**

Camera: **4x5 inch**

Lens: **360mm**

Film: **Kodak Ektachrome 64**

Exposure: **f/32**

Lighting: **Electronic flash: 1 head**

Props & set: **Vase; jug; flowers**

Plan View

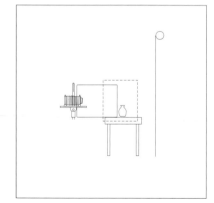

Side View

IT IS SURPRISING JUST HOW MUCH THE RELATIVELY TINY PRODUCT, THE LITTLE "AIDA" PENDANT, DOMINATES THIS PICTURE. THIS IS THE RESULT OF A CAREFUL CHOICE OF PROPS; SKILLFUL COMPOSITION; AND OF COURSE EXCELLENT (THOUGH SURPRISINGLY SIMPLE) LIGHTING.

The lighting is very straightforward: a soft box above and in front of the subject to camera left, supplemented by a bounce behind the subject and to camera right. The three-quarter lighting emphasizes the roundness of the two vessels, while the bounce stops their dark sides from disappearing into the background. The positioning of the soft box is very critical, though, as the centre of the flowered vase must begin to fall into shadow if the pendant is to show to best advantage, and if the chain on the right hand side is to catch the light against the darkness. The dried flowers at the foot of the pots add a dramatic splash of colour and "ground" the picture: cover them with your fingers, and the composition is nothing like as good.

Photographer's comment:

The main thing was to emphasize the name on the jewel.

DEODORANT

▼

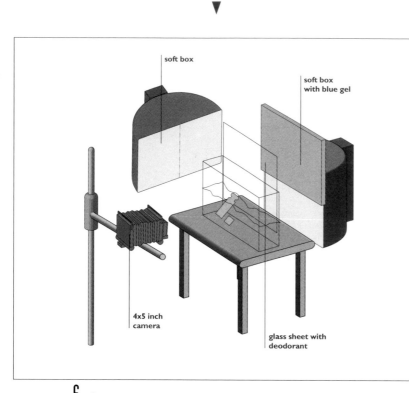

soft box

soft box
with blue gel

4x5 inch
camera

glass sheet with
deodorant

Sr. Segarra modestly describes the lighting on this shot as
"muy sencilla" — very straightforward. So it is; but, as so often, it is the kind of
simplicity which is only simple once you know how it is done.

The way that the deodorant and cap are made to stay in the right relation to one another is ingenious. They are both fixed to a sheet of transparent acrylic material which effectively disappears in the water, and the whole sheet-plus-subject is plunged into the tank. Using the acrylic sheet ensures that the deodorant and the cap remain in precisely the correct relative positions.

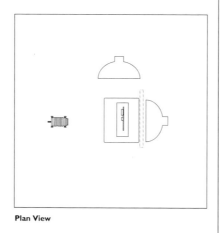

Plan View

Photographer: **Enrique Segarra** Client: **Avon Cosmetics** Use: **Brochure** Camera: **4x5 inch**
Lens: **300mm** Film: **Kodak Ektachrome EPP** Lighting: **Electronic flash: 2 heads** Props & set: **Light box with blue gel.**

Photographer's comment:

The important thing was to maintain the relationship of the product and the cap, in order to allow the text to be fitted around them; they could not just fall at random.

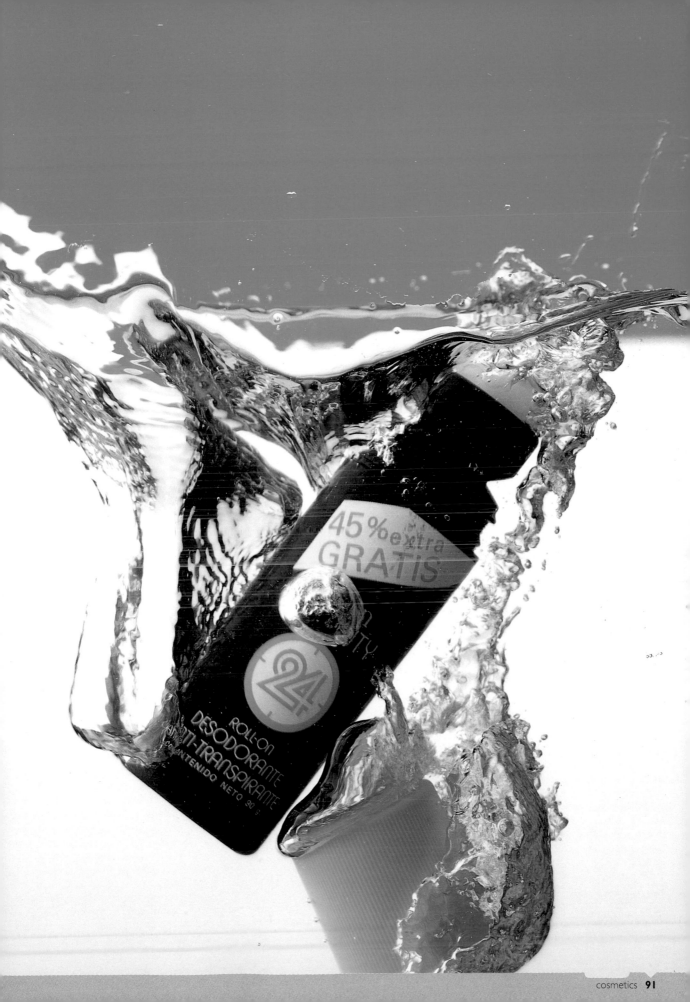

45% extra
GRATIS

24

ROLL-on
DESODORANTE
ANTI-TRANSPIRANTE
CONTENIDO NETO 30 g

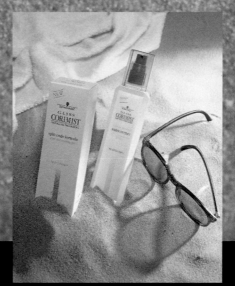

In most kinds of product shots, there are two basic problems. One is that there are many kinds of very similar products on the market, so product differentiation is difficult. The other is that some subjects are inherently almost unphotographable: how much can you say, for example, about credit cards? For that matter, unless it is very unusual indeed, what distinguishes one wristwatch from another?

"Lifestyle" shots represent a convenient and highly acceptable way around this problem. Instead of concentrating on the product, the image concentrates on the props and the surroundings, which are carefully chosen to blend with the aspirations represented by the product.

This is not to say that the product is downplayed. Rather, by careful lighting, it must be emphasized among all the other things in the shot. Also, it must blend naturally with those things, unless of course the aim of the campaign is deliberate incongruity. Few things will destroy the impact of a "lifestyle" shot more surely than claiming too much; for example, by pretending that a particular brand of cheap cigarettes is widely smoked among the nobility and plutocracy. Exactly what is associated with what will depend, too, on where the campaign is to be run: readers of some publications are less sophisticated than readers of others.

Photographer: **Terry Tsui**

Client: **City Chain Co. Ltd.**

Use: **Magazine advertising**

Art director: **Tony So**

Camera: **4x5 inch**

Lens: **210mm**

Film: **Kodak Ektachrome 100 Plus 6105**

Exposure: **f/5.6**

Lighting: **Tungsten: 1 head with honeycomb, plus 3 mirrors.**

Props & set: **Old camera, flowers, and black and white photographs. Background is old wood.**

Plan View

Side View

VINTAGE-STYLE WATCH

▼

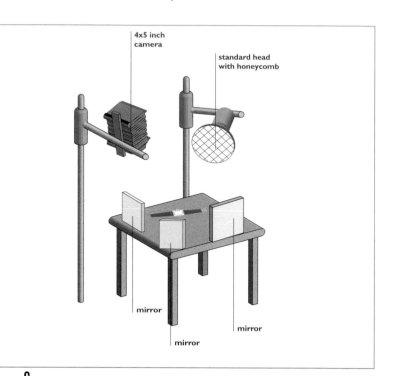

Shooting daylight-balanced film by tungsten illumination is more common in glamour photography than in product shots, but the effect is still useful: nostalic, reminiscent of both sepia and of faded colour. The old folding camera further contributes to the vintage feeling.

A single tungsten light, with small reflector and honeycomb, back lights the picture from camera left; look at the lighting on the flowers and on the camera bellows. Three small mirrors kick light back onto the subject, however: these are the source of the highlights on the back of the lower watch (the one that is seen edge-on), on the camera shutter, and so forth, and also contribute to the pool of light on the principal subject, in this case the watch face.

The black and white pictures are clearly more modern than the ambiance of the shot itself — look at the watch on the man's wrist — but this merely reinforces the message, which is that you can get classic style with modern reliability in a new watch.

Photographer's comment:

Simple lighting can create a warm tone picture. The props were chosen to match the mood of the picture.

Photographer: **Roy Genggam**

Client: **Bank of Central Asia**

Use: **Brochure**

Art director: **Poli Maguiraya (Image Advertising)**

Camera: **6x9 cm**

Lens: **150mm, with soft focus screen for part of the exposure (double exposure).**

Film: **Fuji Velvia ISO 50 pushed to 100**

Exposure: **f/11**

Lighting: **Electronic flash: 7 heads. 1 soft box, 6 reflector heads with medium and small honeycombs.**

Props & set: **Portable phone, electronic organizer, watch, pens; all on a granite background.**

Plan View

Side View

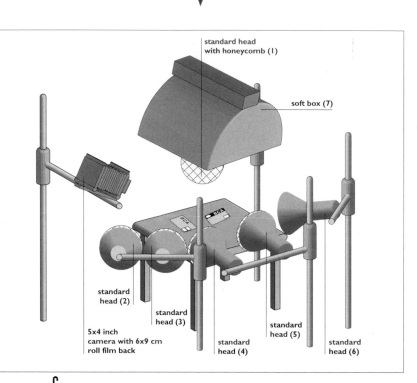

standard head with honeycomb (1)

soft box (7)

standard head (2)

standard head (3)

5x4 inch camera with 6x9 cm roll film back

standard head (4)

standard head (5)

standard head (6)

Credit cards on their own are hardly an exciting subject, so you have to create a "lifestyle" or "ambiance" shot which conveys the impression that these cards are used by successful people. By implication, if you use them, you will be successful too.

In the real world, you often get crossed shadows because something is lit by (say) a window and two lights. You can reproduce this type of light in the studio, but you have to keep the shadows vague and diffuse.

Roy made two exposures. The first used the soft box (7), together with four directional lights. They were (2) with a small honeycomb just below the camera and to the right; (4) with a small honeycomb and an orange filter, to camera right; (5), with a small honeycomb, also to camera right; and (1) to camera left, with a medium honeycomb, for a softer light. The second exposure, with a soft focus screen over the lens, used (3) and (6), both fitted with small honeycombs and orange filters; these are to camera right, at about 5 o'clock and 2 o'clock respectively.

Photographer's comment:

We wanted to make a warm atmosphere product shot on the busy desk.

Photographer: **Andrew Whittuck**

Client: **Penhaligon**

Use: **Advertising brochure**

Stylist/background painter: **Bobby Baker**

Art director: **Flo Bayley**

Camera: **4x5 inch**

Lens: **240mm with 81 filter**

Film: **Kodak Ektachrome 64 Daylight**

Exposure: **f/45**

Lighting: **Electronic flash: 2 heads. 1 60x90cm soft box, 1 spot.**

Props & set: **Silver box, mirror, etc; alabaster vase; painted backdrop and marble background.**

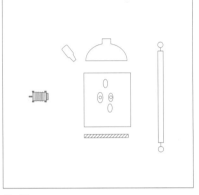

Plan View

Side View

▼

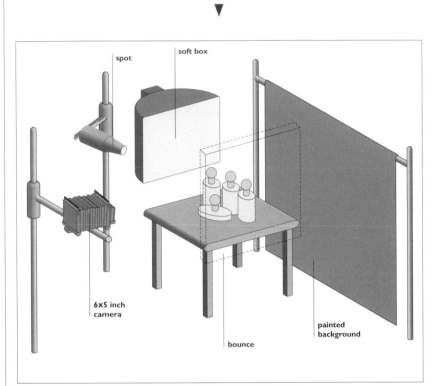

EVERY PRODUCT HAS ITS TARGET MARKET — THE KIND OF PEOPLE WHO LIKE TO IDENTIFY WITH THE IMAGE PROVIDED BY A GIVEN PRODUCT. THE IMAGE HERE IS CLEARLY ONE OF TRADITIONAL AFFLUENCE, WITH A MARBLE DRESSING TABLE AND SILVER AND ALABASTER FURNISHINGS.

The lighting is however surprisingly simple, and undirectional: the classic windowlight-plus-sunlight effect, achieved by using a large soft source (a 60x90cm soft box) plus a small sharp source (a flash spot) from the same direction. There is a bounce card to the right, though the darker elements in the picture are mostly kept to the left where there is more light.

With a shot like this, all the props must be absolutely perfect: the slightest incongruity, or hint of cheapness, destroys the whole image. This can make life very interesting for the photographer or (more usually) for his assistant, who may have to hire or borrow very valuable props. The sprig of foliage, incidentally, had to be clamped (by a lab clamp, just out of shot) to hold it in precisely the right position.

Photographer: **J.M. Godefroid**

Use: **Promotional shot**

Camera: **4x5 inch**

Lens: **240mm**

Film: **Kodak Ektachrome 64 Tungsten**

Exposure: **Not recorded**

Lighting: **Mixed: 2 electronic flash heads, 1 tungsten focusing spot, 1 light brush.**

Props & set: **Location in old house**

Plan View

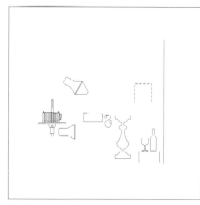

Side View

VIN ET NATURE

▼

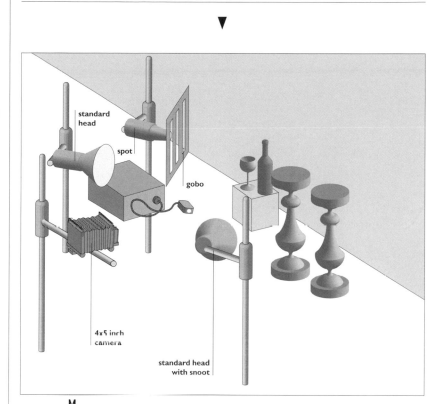

MOST PHOTOGRAPHERS, WHEN THEY MIX FLASH AND TUNGSTEN, SHOOT ON DAYLIGHT-TYPE FILM. HERE, THE PHOTOGRAPHER HAS SHOT ON TUNGSTEN-BALANCE FILM SO THAT THE AREAS ILLUMINATED BY THE FLASH AND THE LIGHT BRUSH ARE VERY COLD AND BLUE, AND THE PARTS ILLUMINATED BY TUNGSTEN LOOK NATURAL.

A standard reflector flash, above the camera and to the left, provides the key for the balusters, though the left-hand baluster is helped out somewhat by the light brush. A snooted flash head to camera right shines between the balusters, illuminating the right-hand one in particular and throwing the spot of blue on the wall behind and beside the bottle. A focusing tungsten spot, sliding through a slatted gobo, creates the "daylight" which illuminates the bottle and (more especially) the glass, as well as creating the streaks of "sun". Finally, the light brush adds a little more to the label and to parts of the foreground.

Such a picture might or might not appeal to a particular client as a commercial product shot; but its originality of ideas and techniques might well lead to a commission using a similar approach.

Photographer's comment:

I wanted a deliberately cold ambiance with a touch of warmth on the product (the wine), conveying the way that wine brings comfort even in the most desolate and depressing of surroundings.

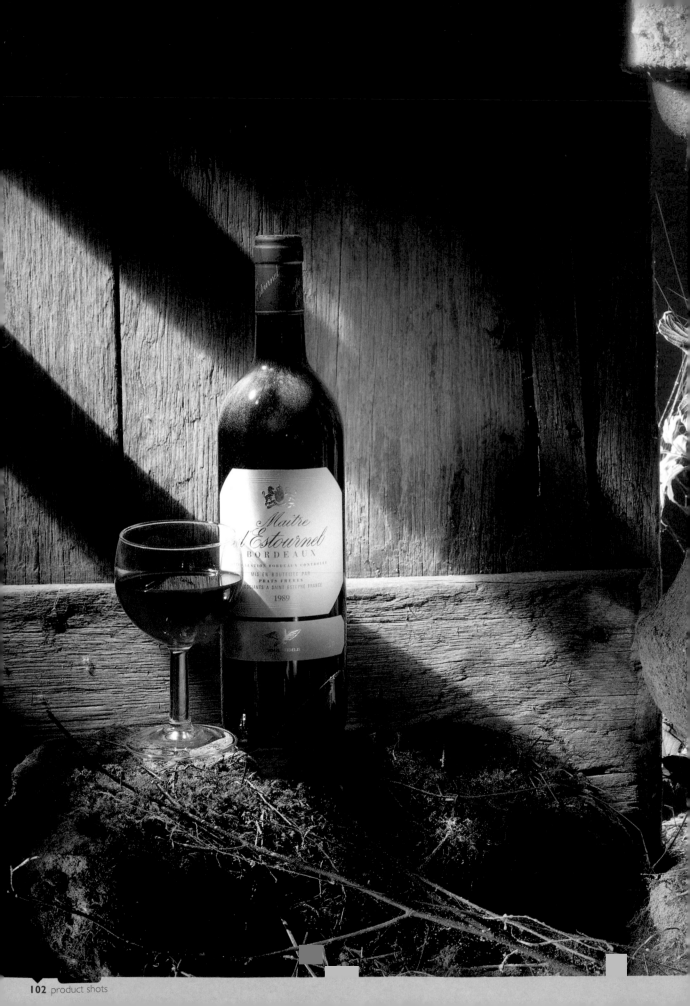

Photographer: **Allan Hewett**

Client: **Schwarzkopf**

Use: **Editorial**

Camera: **4x5 inch**

Lens: **150mm**

Film: **Fuji Velvia**

Exposure: **I second at f/16-1/2 (f/19)**

Lighting: **Mixed: I electronic flash balanced to tungsten, 2 tungsten, I in 350mm reflector, I focusing spot with yellow gel.**

Props & set: **Silver sand, yellow hand towel, sunglasses.**

Plan View

Side View

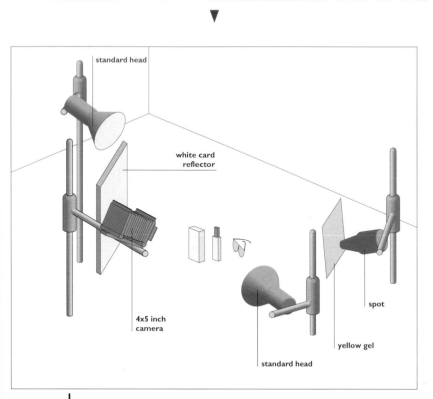

standard head

white card reflector

4x5 inch camera

standard head

spot

yellow gel

Like the shot by Pauline Mary Stevens on pages 106/107, this picture by Allan Hewett shows how much you can suggest with a small set, a few well-chosen props, and the right lighting. Shooting daylight-balanced film with tungsten-balanced illumination creates the ambiance of late sun.

The key is a focusing tungsten spotlight with a yellow gel, just above floor level, which casts the dramatic shadow of the sunglasses (note the amber lenses) and highlights the edges of the packs. This is of course a back light, at about 45 degrees to the camera/subject axis.

A further tungsten lamp, in a 14inch (350mm) reflector is again just above floor level at camera right to provide fill. The main light on the product comes from a flash head in a 14inch (350mm) reflector, balanced to tungsten lighting.

The packs are propped up with 35mm film canisters filled with sand, and a little adhesive helped to make the sand stick to the bottom of the box on the left.

Photographer's comment:

It provides a summer image, doesn't distort the pack representation, and covers the rough edges of a "mock up".

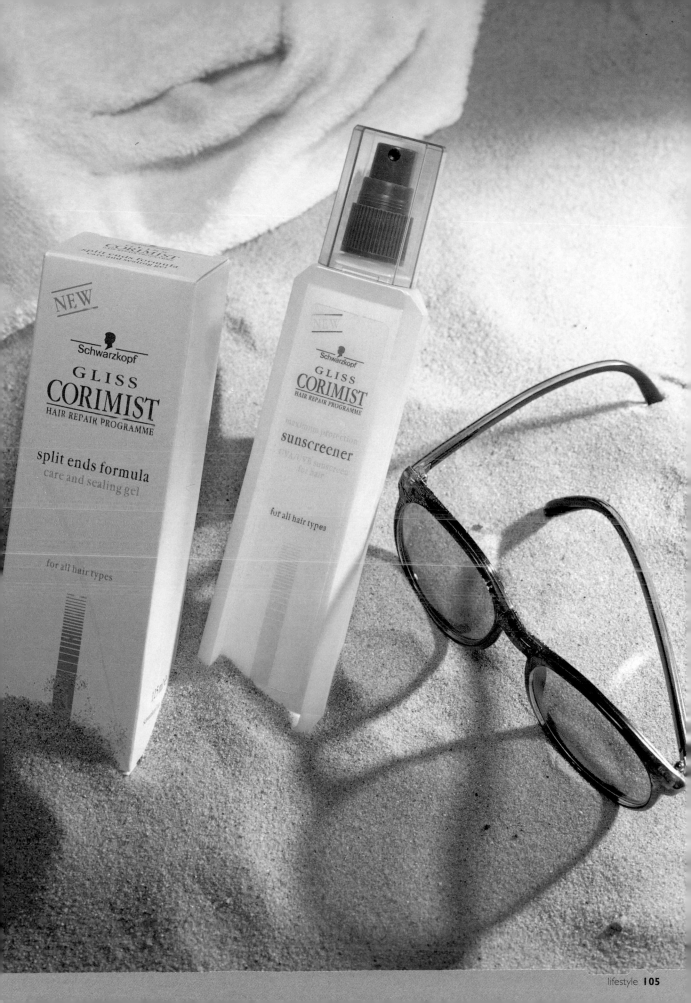

ROYAL DUTCH CIGARS

Photographer: **Pauline Mary Stevens**
Client: **Portfolio shot**
Camera: **4x5 inch**
Lens: **210mm**
Film: **Kodak Ektachrome EPY 64**
Exposure: **Not recorded, but probably** **¹/4 second**
Lighting: **Tungsten**
Props & set: **Boxes and wood**

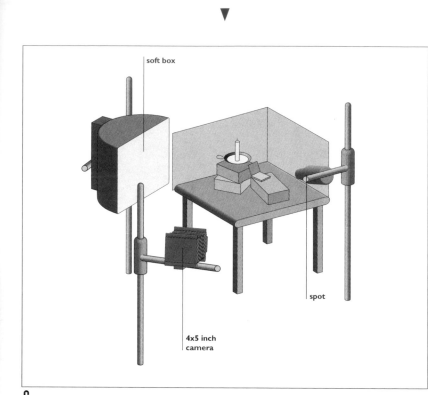

soft box

4x5 inch camera

spot

Conversation, deep into the night; old friends talking; a rather spartan, masculine environment: it is surprising how much you can suggest with relatively simple props and moody lighting. Close control of all the tones and colours, keeping to a warm brown, adds still further to the picture.

There are two difficulties with including a light source in the picture. One lies in keeping it natural, without burning out to a white blur on the one hand or collapsing to a glow-worm on the other. The second problem lies in avoiding awkward shadows: the light source must look as if it is there to supply illumination, rather than being swamped by external light sources. Of course, many Hollywood adventure movies break this elementary rule.

You can however give yourself a great deal of flexibility by using electronic flash, as flash exposure is affected only by aperture, while the exposure of a continuous source is affected by both aperture and shutter speed. Here, a soft box to camera left provides the key, while a spot to camera right provides a modest degree of fill and illuminates the product.

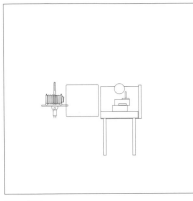

Side View

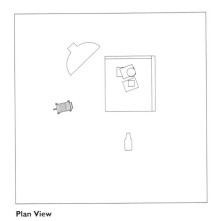

Plan View

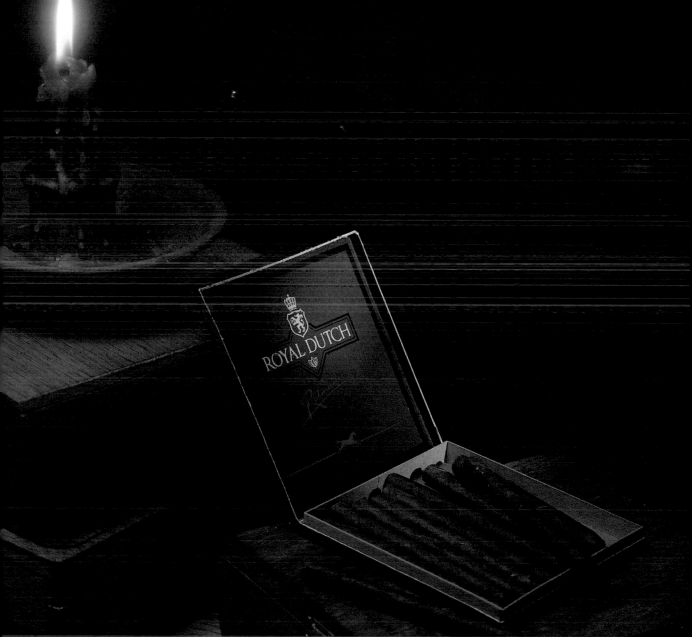

CAMPING

▼

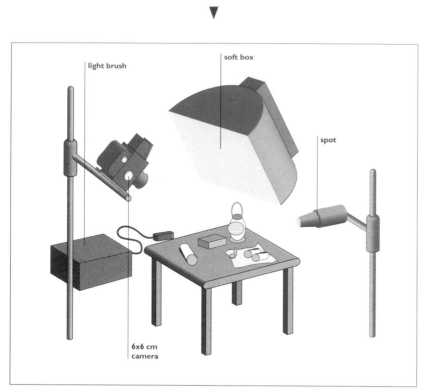

light brush

soft box

spot

6x6 cm
camera

Tobacco advertising is not politically correct nowadays, and there are some photographers who will not do it; but national attitudes vary, and so do national requirements. Associating cigarettes with healthy outdoor activities is a traditional way of selling them.

A soft box provides the overall lighting while a spot back light is set just to the right of the camera/subject axis and very low, in order to create the shadows. A light brush modifies this "fill/key" set-up extensively. Using heavy yellow filtration over the spot and the light brush, except for the illumination of the cigarette packet helps the subject to stand out.

Plan View

Photographer: **Edwin Rahardjo** Client: **Wismilak Diplomat Cigarettes** Use: **Calendar** Art director: **Yanto S** Camera: **6x6 cm** Lens: **150mm** Film: **Kodak EPR ISO 100** Exposure: **f/22** Lighting: **Electronic flash (2 heads) plus light brush** Props & set: **Camping gear and canvas background**

Photographer's comment:

The client wanted the picture to convey a warm, attractive image (in the form of camping) while leaving the product clear but not too dominant.

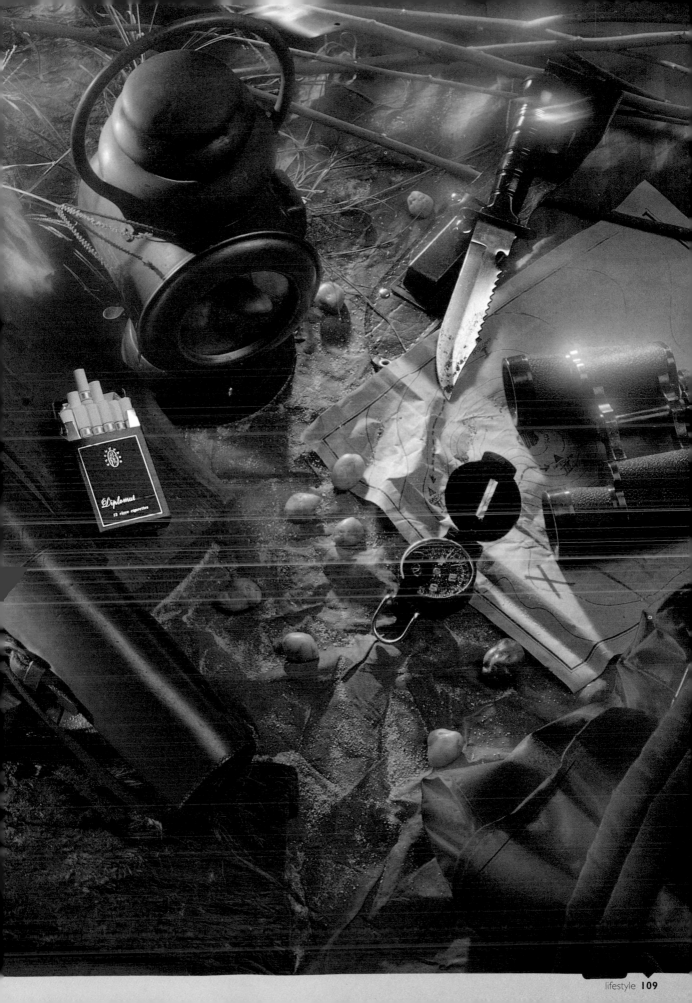

Photographer: **Mike Dmochowski**

Client: **The Design Agency**

Camera: **4x5 inch**

Lens: **240mm**

Film: **Kodak T-Max ISO 100 printed on Kodak colour paper to give sepia/brown tone**

Exposure: **Not recorded**

Lighting: **Mixed flash and tungsten**

Props & set: **Paper background**

Plan View

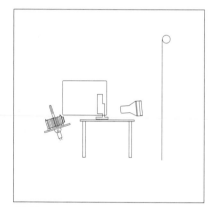

Side View

F A N

▼

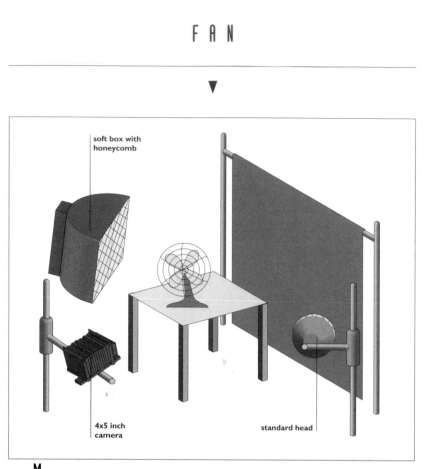

soft box with honeycomb

4x5 inch camera

standard head

Mixing flash and tungsten on black and white film leads to no problems with colour casts, of course, but the sensitivity of the film to different light sources may vary — and it will not be identical to the sensitivity of Polaroids!

There is no true "key" in this lighting set-up, as the image is effectively a silhouette plus highlights. The exposure was made partly by flash to freeze the fan blades, and partly by tungsten light to let them blur: the modelling lights in a flash head are very good for the latter purpose. Above the camera and to the left, a honeycombed soft box provided some definition in the fan and created highlights and reflections, while the reflector-plus-honeycomb

background light illuminated the paper background. A low camera angle emphasized the looming nature of the fan.

The result is a most unusual and memorable image which clearly demonstrates how to "break the rules" in order to create a truly original shot. Mike Dmochowski has all but ignored conventional technical quality, while remaining clearly in control at every stage of the process.

Photographer's comment:

I used the movements of my 4x5 inch camera to "throw" the focus on the fan.

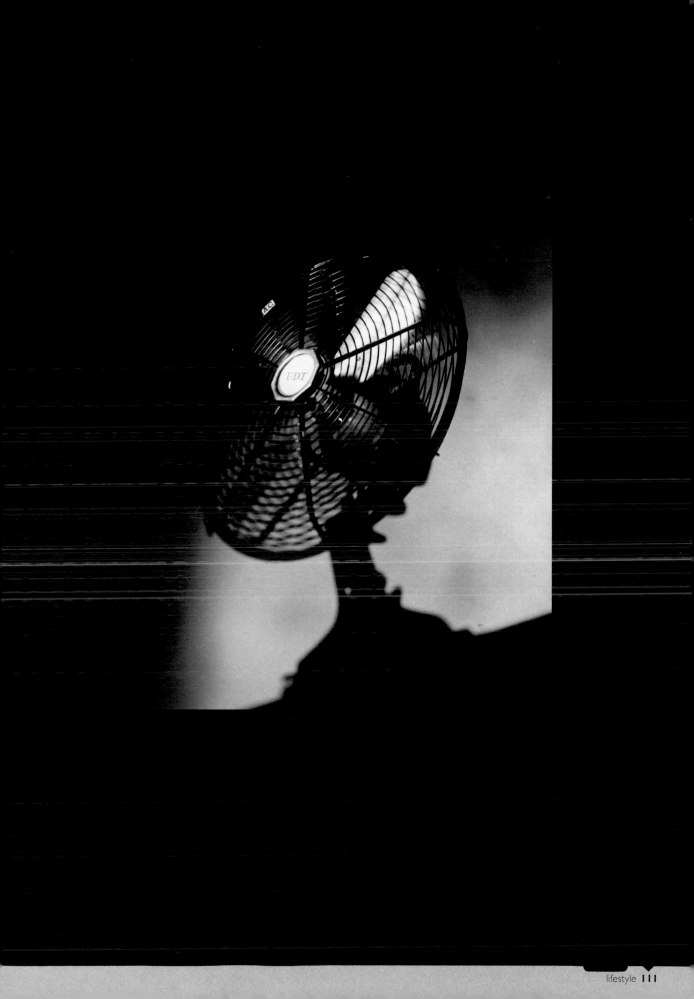

6

electrical and
mechanical
devices

► Product shots for electrical and mechanical devices can be divided into two groups: those for a general audience, and those for an informed audience. The former are much like any other advertising shot, in that the product is to a large extent taken for granted. After all, within a given price bracket, most hi-fi units or most cameras will have fairly similar features and specifications. Shots for an informed readership, on the other hand, turn on whatever differences exist: the product must be seen as clearly as possible. Where the same picture must appeal to both the informed and the uninformed readership, it must sell to one reader on visual appeal, and to another on features, control layout, and so forth.

At least with consumer goods, there is a conscious attempt on the part of the manufacturer to give his product visual appeal; but with many specialist components or whole items, visual appeal may be completely irrelevant. Either the product is out of sight, as (for example) a circuit board or a connector inside a computer, or it is something which in the normal course of events will be seen only by a service or maintenance engineer. Making this sort of thing visually interesting can be a real challenge; but it is one which has been met by the pictures on these pages.

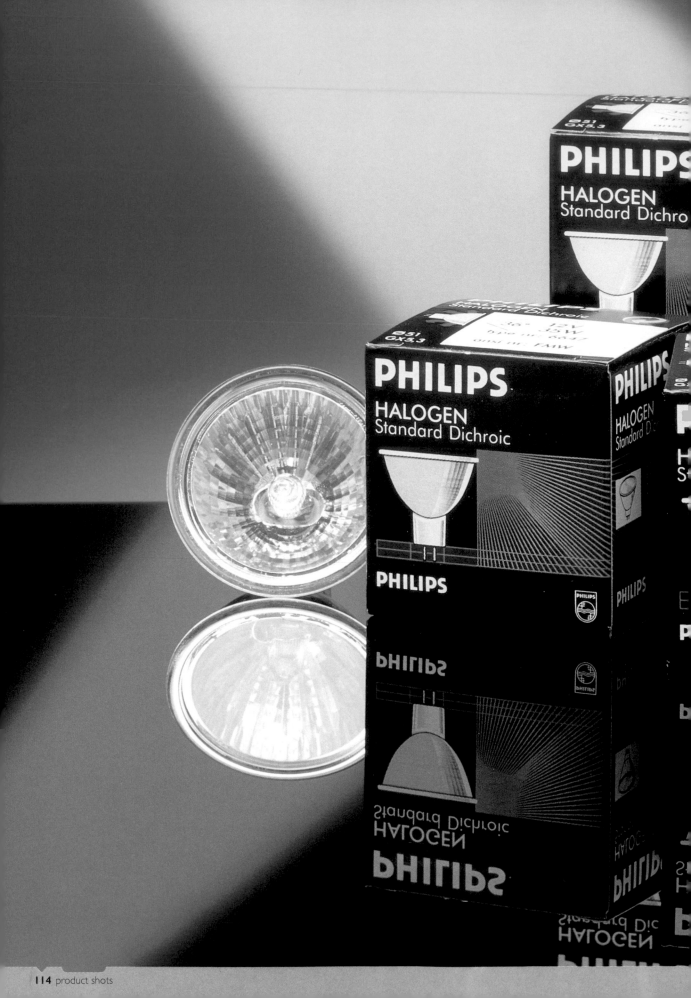

Photographer: **Richard Painter**

Client: **Philips Lighting Ltd.**

Use: **Brochure**

Camera: **6x7 cm**

Lens: **240mm**

Film: **Fuji RDP ISO 100**

Exposure: **f/32 (double exposure)**

Lighting: **Electronic flash: 3 heads. 1 soft box, 2 background lights, 1 filtered Roscolene No. 862 (True Blue).**

Props & set: **Stock background**

Plan View

Side View

▼

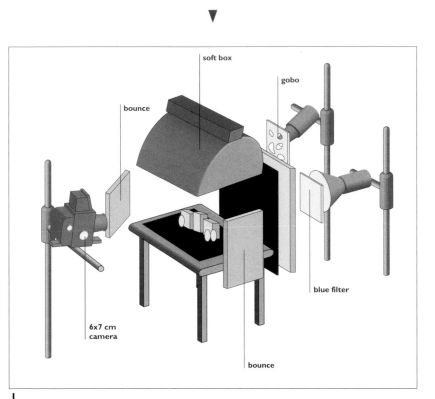

IN A CLASSIC PRODUCT SHOT LIKE THIS ONE, YOU NEED TO SHOW THE BUYER WHAT IS IN THE PACK, SO THAT HE OR SHE KNOWS THAT IT IS WHAT THEY WANT, AND THE PACK ITSELF, SO THAT THE BRAND NAME REGISTERS AND THEY RECOGNIZE THE PACK IN THE SHOP.

A large soft box directly over the set lights the subject, and also has the intriguing effect of making the reflections of the lights brighter than the lights themselves, because of the angles of reflection. This means that you can see detail as well as having an overall impression of brightness. Reflectors on either side of the set provide fill and also reflect from the edges of the lamps to provide perfect differentiation from the background.

The background itself is lit with two lights: one with a circular reflector and a strong blue gel, and the other shining through a specially cut gobo to create the streak of blue light. Both foreground and background lighting were balanced to f/32, then exposed separately, first with the key light off and then with the background covered in black velvet.

Photographer's comment:

As the shot was to appear quite small in a brochure, I needed a strong image to grab the reader, but which would also describe the product clearly.

Photographer: **Robert Stedman**

Client: **Molex Singapore**

Use: **Brochure**

Camera: **6x7cm**

Lens: **140mm**

Film: **Kodak EPPI SO 100**

Exposure: **f/22-1/2 (f/27)**

Lighting: **Electronic flash: 2 heads, 1 with purple gel, plus reflectors.**

Props & set: **Spray painted circuit boards, frosted matte plastic background.**

Plan View

Side View

MILLIGRID CONNECTORS

▼

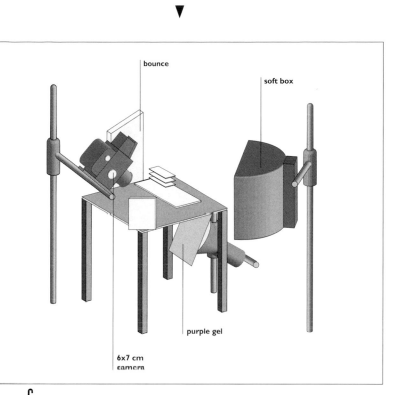

CIRCUIT BOARDS ARE ONE THING, BUT SHOWING HOW CIRCUIT BOARDS INTERCONNECT IS QUITE ANOTHER. HOW DO YOU DECREASE THE EMPHASIS ON THE BOARDS, AND INCREASE THE EMPHASIS ON THE CONNECTORS? ROBERT STEDMAN DID IT BY SPRAYING THE BOARDS WHITE, LEAVING ONLY THE CONNECTORS UNPAINTED.

Then, the problem was one of white-on-white, compounded by the small size of the connectors in the shot. This is where the lighting, and the arrangement of the boards, came in.

The translucent plastic background is transilluminated by a standard reflector head with a purple gel over it. The boards themselves are lifted above the ground, and above each other, by wooden blocks carefully concealed out of shot. The key, above the set and slightly back lighting it from camera right (look at the shadows) is a soft box; two reflector cards, one opposite the main light and one to camera right, provide some fill and also add highlights to the connectors.

As with other pictures in the book, the description of how it is done is much less interesting than the picture itself.

Photographer's comment:

This shot was used as a cover for a brochure. The client wanted to show how the boards interconnect. At the same time, we had to make it look interesting.

Photographer: **Looi Wing Fai**

Client: **AP/FCB**

Use: **Press advertising**

Art director: **Barney Chua**

Camera: **4x5 inch**

Lens: **150mm**

Film: **Kodak Ektachrome EPP**

Exposure: **f/64 & f/11 (foreground double exposed)**

Lighting: **Electronic flash: 4 heads.
2 diffused to give soft light, 1 effects light,
1 background light.**

Props & set: **Technics equipment on black Perspex**

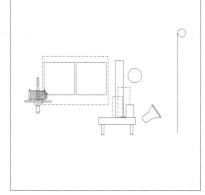

Plan View

Side View

▼

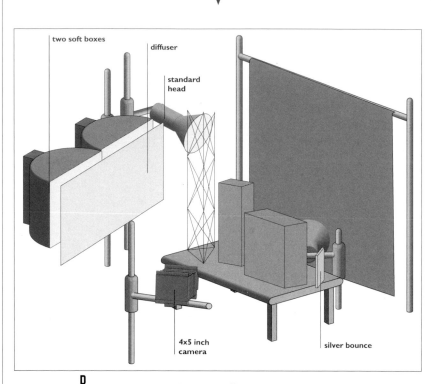

two soft boxes

diffuser

standard head

4x5 inch camera

silver bounce

Black-on-black, the "high-tech" look, is a favourite with hi-fi manufacturers. The problem (as in so many product and pack shots) lies in differentiating superficially similar products from one another. It is also worth noting that camera movements were used to keep verticals parallel.

The key light is two large soft boxes, diffused through tracing paper, to camera left and all but facing the subject square-on. This gives the shadows, and the bright reflections on the face of the equipment stack, the control knobs, and the speaker surrounds. A small effects light back lights the set from camera left, principally to give the highlight along the left edge of the speaker and to differentiate it from the background. The fourth light is another small effects light which illuminates the background.

What really differentiates the equipment from the background, however, is the double exposure of a textured surface (painted canvas) through the foreground, which was achieved by very precise masking in front of the camera lens; this lifts the picture from the run-of-the-mill, black-on-black of other hi-fi shots.

Photographer's comment:

Using a double exposure technique made the product look much more prominent.

HARD LABOUR

Photographer: **Raymond Tan**

Client: **Sony International**

Use: **Magazine and press advertising**

Art director: **Henry Chan (Sil Ad, Singapore)**

Camera: **4x5 inch**

Lens: **210mm**

Film: **Fuji RDP ISO 100**

Exposure: **f/32**

Lighting: **Electronic flash: 3 heads**

Props & set: **Set built by professional props maker according to visual layout; background spray paint on large art card**

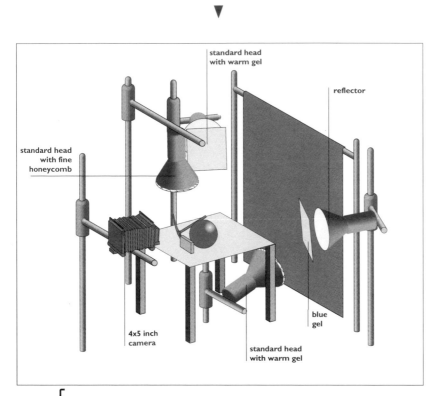

- standard head with warm gel
- reflector
- standard head with fine honeycomb
- blue gel
- 4x5 inch camera
- standard head with warm gel

Even its dearest friends and most fervent admirers would have to admit that a data storage cartridge is not visually exciting; so the challenge became to emphasize the ruggedness and reliability of the product, with a "chain gang" setting.

The background light, with a warm gel over it, is close to the background (about 50cm/18inches away) in order to control the spread of the light. A standard head to camera left is fitted with a warm gel, and illuminates the table top and the tip of the pick, back lighting them slightly. Another standard head in a slightly larger reflector is used to camera right to illuminate the ball and chain; again, it back lights the subject slightly to help create the dark area on the ball, just behind the data cartridge. This light has a blue gel on it. Finally, a small light head directly over the subject, with a fine honeycomb and no gel, highlights the "star" of the picture. A little dry ice behind the ball, and just out of shot to camera right, creates the effect of early morning mist.

Photographer's comment:

The aim was to create a harsh environment while making sure at the same time that the small Sony Data Cartridge is not lost in the overall composition.

Side View

Plan View

Photographer: **Robert Stedman**

Client: **Molex**

Use: **Brochure cover**

Camera: **4x5 inch**

Lens: **140mm**

Film: **Kodak Ektachrome EPP ISO 100**

Exposure: **f/32**

Lighting: **Electronic flash: 2 heads. Soft box and standard head with honeycomb.**

Props & set: **Calipers, magnifying glass, drawings. Background is blue Formica and a glass sheet.**

Plan View

Side View

2.0 PITCH CONNECTORS

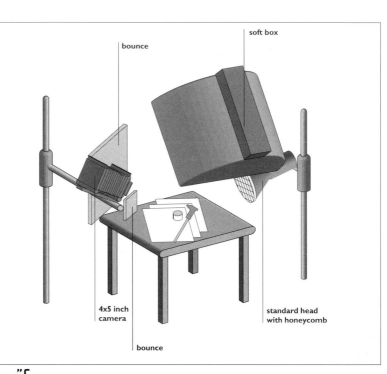

"FLOATING IN THE AIR" SHOTS, WHERE THE PICTURE ELEMENTS ARE CLEARLY SEPARATE BUT WITHOUT VISIBLE MEANS OF SUPPORT, ARE SO COMMONPLACE THAT WE HARDLY GIVE THEM A SECOND LOOK. BUT THEY CAN BE SURPRISINGLY HARD TO SET UP AND TO LIGHT, UNLESS YOU KNOW WHAT YOU ARE DOING.

The three sets of blueprints are supported on cards and held apart from one another by wooden blocks. The sheet of glass carrying the magnifier, the calipers and the connectors themselves is clamped to a stand just out of shot.

The key, to camera right and above the set, is a soft box; a white fill card to camera left, and a smaller silver fill card below the camera and to the left, provide fill lights and also highlights. A small head with a grid spot provides the blue glow on the background.

The main problem lies in getting everything evenly lit, without awkward crossed shadows and without some parts of the subject being much brighter than others, and careful use of fill cards is a major part of this.

Photographer's comment:

This was a cover shot for a brochure to introduce new connectors. We had to convey that the connectors could be custom-made to specific customer requirements.

Photographer: **Matthew Leighton**

Client: **Energex**

Use: **Advertising**

Camera: **4x5 inch**

Lens: **75mm and 240mm**

Film: **Fuji RDP 100**

Exposure: **Quintuple exposure – see text**

Lighting: **Main shot: electronic flash, 4 heads. 3 soft boxes, spot with blue gel.**

Props & set: **Background: eclipse of the sun.**

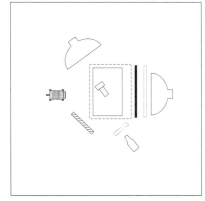

Plan View

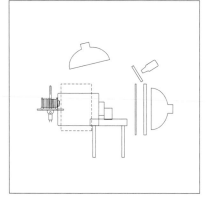

Side View

R E C H A R G E A B L E T O R C H

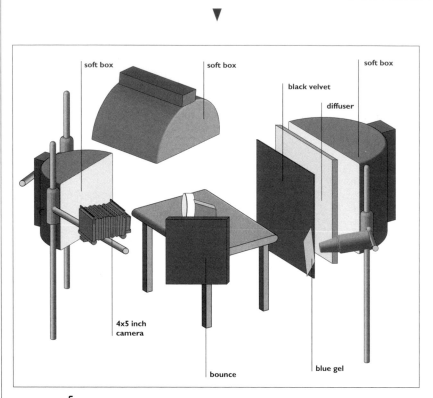

Fɪᴠᴇ ᴇxᴘᴏsᴜʀᴇs, ᴛʜʀᴇᴇ sᴇᴛs, ᴛᴡᴏ ʟᴇɴsᴇs – ᴀ ᴄᴏᴍᴘʟᴇx ᴘɪᴄᴛᴜʀᴇ. Bᴜᴛ ᴛʜᴇ ғᴏᴜʀᴛʜ ᴀɴᴅ ғɪғᴛʜ ᴇxᴘᴏsᴜʀᴇs (ᴡɪᴛʜ ᴛʜᴇ 240ᴍᴍ ʟᴇɴs) ᴡᴇʀᴇ ᴄᴏᴍᴘᴀʀᴀᴛɪᴠᴇʟʏ sɪᴍᴘʟᴇ: ᴛʜᴇ AC ᴀᴅᴀᴘᴛᴇʀ ᴏɴ ʙʟᴀᴄᴋ ᴠᴇʟᴠᴇᴛ, ʟɪᴛ ʙʏ ᴀ sɪɴɢʟᴇ sᴏғᴛ ʙᴏx, ᴀɴᴅ ᴛʜᴇ "ᴄᴀʙʟᴇs", ᴡʜɪᴄʜ ᴡᴇʀᴇ sʟᴏᴛs ᴄᴜᴛ ɪɴ ʙʟᴀᴄᴋ ᴄᴀʀᴅ ᴀɴᴅ ᴄᴏʟᴏᴜʀᴇᴅ ᴡɪᴛʜ ɢᴇʟs.

The first three exposures, with a 75mm lens at f/45, were all of the main set: the torch resting on the rusty batteries. The first exposure was lit with two medium soft boxes, one above and in front of the set (in fact, above the camera) and one to camera left and in front of the set, and a spot with a blue gel. The second was one minute with all lights off except the torch bulb. The third had only the back light on, shining through an acrylic diffuser, to provide a light source: a 4x5inch transparency (duped up from 35mm) of an eclipse of the sun was placed inside the camera to create the background — the torch and batteries provided the mask. The main problem with a shot like this is keeping track of where you are!

Photographer's comment:

Turning an ordinary product shot into a powerful image is lots of fun. I wanted the image to speak for itself without the need for lots of text. The hardest part was how to oxidize the new batteries in a matter of hours.

Photographer: **Allan Hewett**

Client: **Storm Advertising/Sauter USA**

Use: **Account Pitch**

Camera: **5x7 inch**

Lens: **180mm**

Film: **Fuji RTP 64T**

Exposure: **5 seconds at f/32**

Lighting: **Tungsten, white card & mirror.**

Props & set: **Black velvet and corrugated PVC roofing**

Plan View

Side View

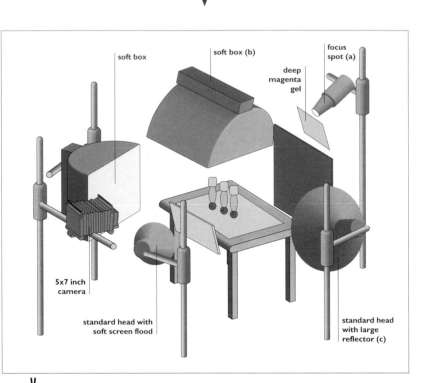

V ALVES LIKE THESE ARE THE ARCHETYPAL "WIDGETS" OF THE ENGINEERING WORLD. THEY HAVE TO BE VERY CLEARLY DELINEATED, SO THAT THE SPECIALIST BUYER CAN SEE EXACTLY WHAT THEY ARE AND WHAT THEY DO, BUT THEY ALSO HAVE TO BE PRESENTED IN A WAY WHICH MAKES THEM LOOK ATTRACTIVE.

Allan Hewitt's description of setting the shot up is wonderfully succinct. "Clean product, polish brass and apply gold cosmetic theatrical powder to case of left-hand unit. Focus spot A spread beam through large suspended gel. Soft box B, 100x100cm, forward top, two feet (60cm) above. Light C is 30inch (75cm) round light with disc diffuser approximately 6 inches above the base board to right rear of product. Fourteen inch (35cm) soft screen to right and just above camera. White card "kicks" in front, with mirrors; fine dulling spray highlights the front and helps the black bits".

The end result is a picture which certainly grabs the attention, even if one does not have the faintest idea what the valves do; the image is of a company which understands and cares about good design.

Photographer's comment:

My client asked me to produce a shot to make the marketing director 'sit up and take notice'. My client won the account.

Photographer: **Roger Hicks**

Client: **David & Charles**

Use: **Book cover**

Camera: **4x5 inch**

Lens: **203mm**

Film: **Fuji RDP 100**

Exposure: **f/22-1/2 (f/27)**

Lighting: **Electronic flash: 2 heads, 1 soft box, 1 in standard 7inch (180mm) standard reflector, plus shaving mirrors and white reflectors.**

Props & set: **White seamless paper**

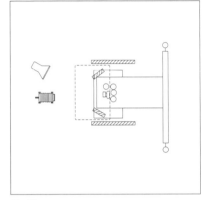

Plan View

Side View

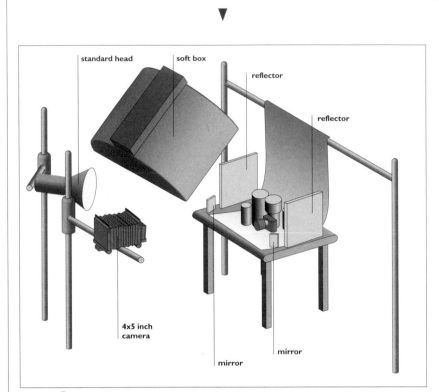

BLACK-ON-BLACK IS ALWAYS AWKWARD TO LIGHT, AND THE ONLY WAY TO DO IT IS TO RELY ON THE DIFFERENT REFLECTIVITY OF THE VARIOUS SURFACES: SHINY BLACK, DULL BLACK, MATTE BLACK AND SO FORTH. SLIGHT OVEREXPOSURE HELPS, TOO.

The key light was a soft box above the subject and slightly in front of it, i.e. towards the camera, pointing back at the subject.

Although this provided the basic light, and avoided overexposing the chrome parts of the cameras and lenses, large polystyrene reflectors left and right were needed to create roundness in the lenses. An additional light to camera left set three stops down (f/8-1/2), gave some highlights without creating crossed shadows. A shaving mirror to the left of the subject created an additional highlight on the left side of the Pentax, to differentiate it from the lens behind, and another shaving mirror gave a highlight on the right-hand side of the Nikon lens for the same purpose.

Photographer's comment:

This was the central image for a book cover; other images (photographs from inside the book) were comped around it. The aim was to show how lenses from an independent manufacturer (in this case Sigma) could be used with other leading manufacturers cameras both old (Nikon F) and new (Pentax Z1).

Photographer: **Nishide Atsuo**

Use: **Work for exhibition**

Camera: **4x5 inch**

Lens: **240mm**

Film: **Kodak Ektachrome EPY**

Exposure: **f/22; shutter speed not recorded.**

Lighting: **Tungsten**

Props & set: **Leaves; green background paper.**

Plan View

Side View

▼

THE DISCMAN IS SUPPORTED BY THE CLASSIC MEANS OF A LONG, FIRM POLE PIERCING THROUGH THE BACKGROUND AND THEREFORE CONCEALED BEHIND THE SUBJECT. AFTER THAT, AND OF COURSE AFTER HAVING THE IDEA IN THE FIRST PLACE, IT IS MERELY A MATTER OF GETTING THE LIGHTING BALANCE PERFECTLY RIGHT.

The main light is a 1K tungsten lamp in a large "scoop" reflector, diffused through tracing paper. This is to camera right at about 45 degrees to the camera/subject axis. Fill comes from a 500w light to camera left, diffused the same way and symmetrically placed. A small 500w spot with an opal filter illuminates the background, helping to differentiate the rear edge of the Discman from it.

What is really intriguing about this picture, apart from its style and impact, is that it could be duplicated by most amateur photographers: the lighting set-up is neither particularly complex nor particularly expensive. Nor does it require a great deal of space; it could have been done in a garage or even a large room. All it requires is a strong personal vision, followed by some time and determination.

Photographer's comment:

A composition of an object with leaves.

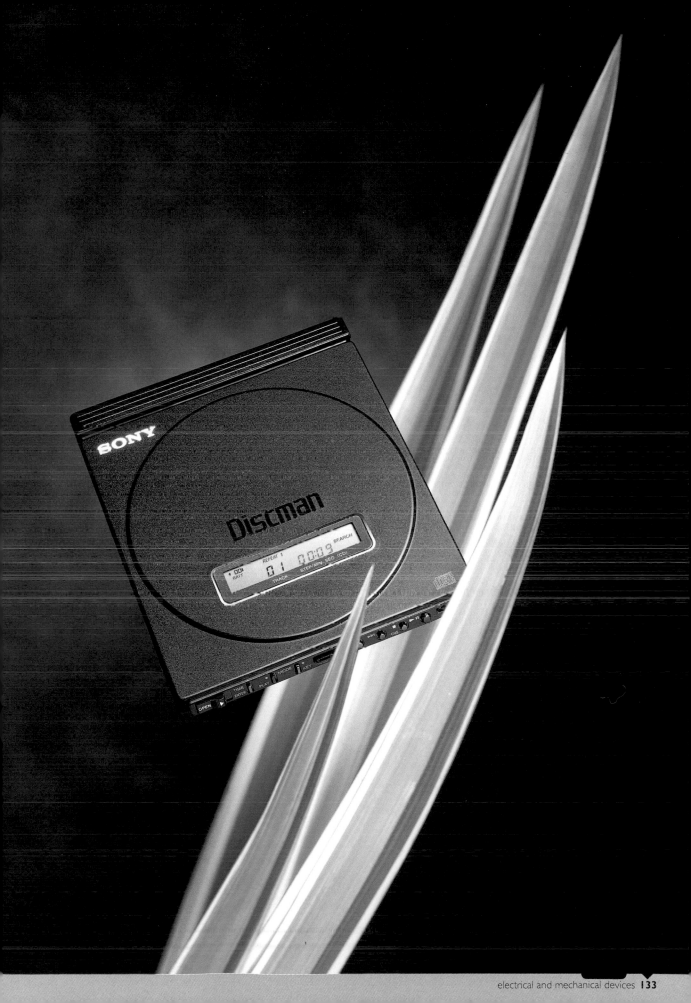

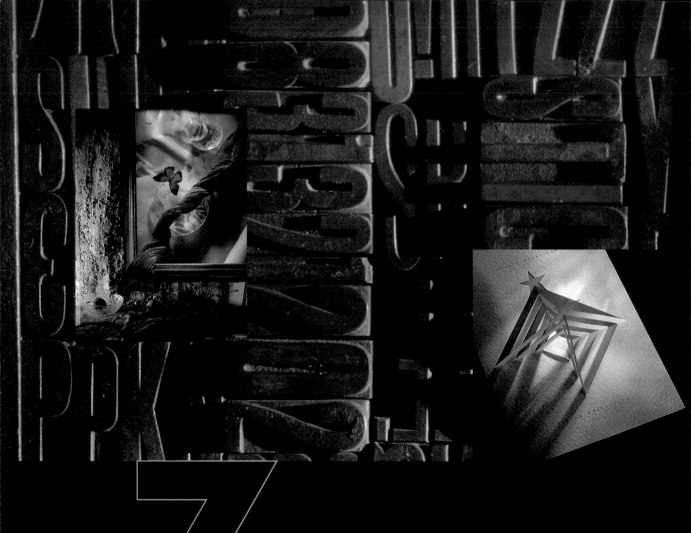

Some product shots defy categorization, either because of the subject matter or because of the way in which they are photographed. A book, for example, could be presented as part of a "lifestyle" shot; or equally (as in the picture on pages 142/143), the photograph can illustrate a scene from the book, or the kind of situation described by it. As for a greetings card – well, to see a novel way of photographing a greetings card, turn to pages 148/149.

Most of the shots in this chapter have been chosen principally because they illustrate a particular technique or approach. This may either be highly original, or simply an unusually good rendition of a more conventional representation.

Inevitably, there will be some problems which remain unanswered by the illustrations in this chapter or in the rest of the book; as this chapter demonstrates, there are always new problems, new ideas, new products. It is never possible to provide a "one size fits all" solution to product photography or to any other type of photography. We hope, however, that we have provided a warehouse of ideas which can be adapted to the new challenges which every photographer faces daily in his or her work.

Photographer: **Artli Ali Hawijono**

Client: **KIG Group (Tableware)**

Use: **Calendar 1991**

Camera: **4x5 inch**

Lens: **210mm**

Film: **Fuji**

Exposure: **f/22 – Double exposure**

Lighting: **Electronic flash: 3 heads.
1 soft box, 2 with standard reflectors.**

Props & set: **In-house studio props,
background of cardboard splashed
with cement.**

Plan View

Side View

▼

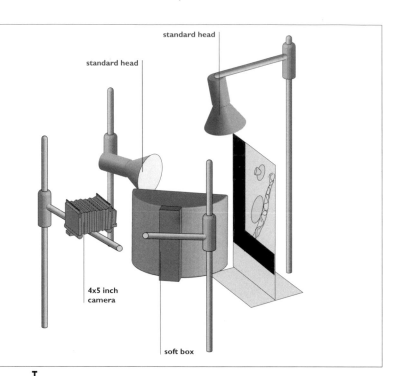

standard head

standard head

4x5 inch
camera

soft box

THIS PICTURE WAS DOUBLE EXPOSED IN ORDER TO GET PRECISELY THE RIGHT LIGHTING ON BOTH THE PAINTING ON THE WALL AND THE ROUGH-TEXTURED WALL ITSELF; IN BOTH CASES, THE AREA TO BE LEFT BLANK WAS COVERED WITH BLACK VELVET.

The first exposure was of the painting – which shows the product in the form of the glass cup and saucer and the plate – and the twisted fabric which runs diagonally across it. The "L" shape to the left and below was masked with black velvet. Lighting came from a large soft box slightly above the painting and slightly to camera right (to avoid "flashback"

from the painting) and from a standard reflector head directly above the painting to provide a grazing light which highlights the fabric.

The second exposure, this time with the painting masked out with black velvet and the twisted fabric removed, was of the actual product (the glass bowl in the lower left-hand corner), the fruit, and the rough-cast wall.

Photographer's comment:

I wanted a three-dimensional look, so that the painting on the wall would look alive.

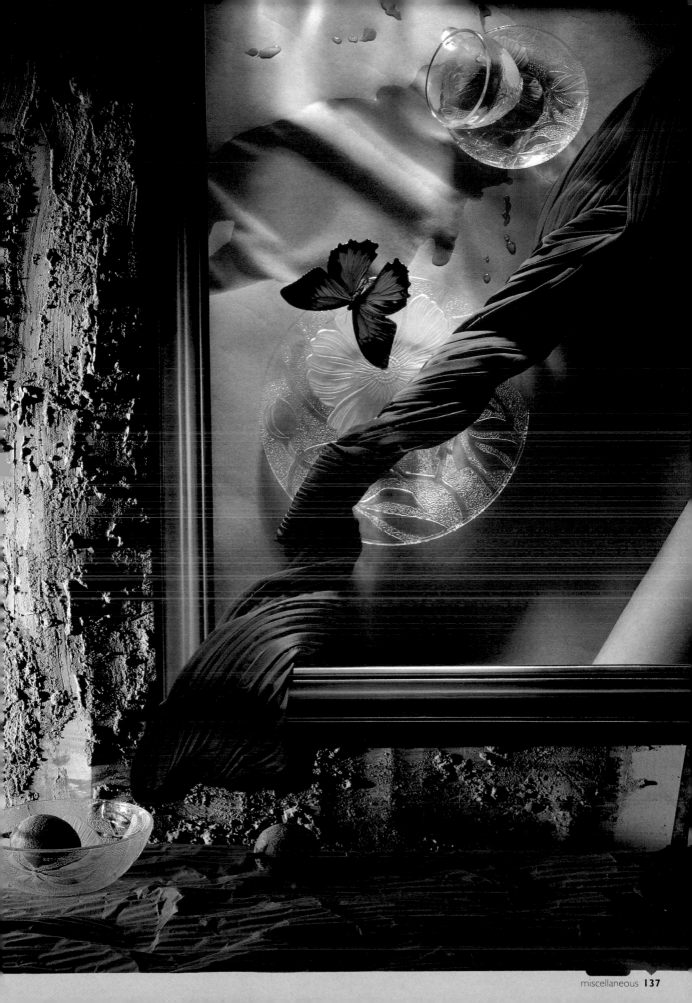

Computergesteuerte Industrie neben
klassischem Handwerk. Zwei Bereiche, die
sich gegenseitig weiterbringen.

Computergesteuerte Industrie neben
klassischem Handwerk. Zwei Bereiche, die
sich gegenseitig weiterbringen.

Wir managen ihn gern, den Prozess, der die
bedruckten Planobogen zum eigentlichen Buch oder
zur Broschüre macht. Dabei sprechen wir nicht
nur vom Hardcover-Einband, der den ideellen Wert
einer Buchausgabe zusätzlich erhöht. Wir sprechen
auch von den vielen Softcovers für Geschäftsberichte,
Kataloge, Magazine und so weiter. Auch in diesem
Bereich zeigt sich Qualität, wenn sie innerhalb
möglichst tiefer Kosten das Optimum ermöglicht.

Wir von Bubu realisieren bereits seit über 50 Jahren
alle Arten von Buchbinde-Lösungen; sei dies auf
der Buchstrasse, die dank modernster Technik täglich
bis zu 15'000 Bücher verarbeitet, oder auch auf der
Broschürenstrasse. Oder sei dies im Atelier, wo
Kreativität und Handwerk den Büchern die schönste
Form verleihen.

Im Zentrum der rationellen Auftragsabwicklung
stehen jedoch immer unsere rund 100 Mitarbeiter, die
mit Freude und Professionalität zur Sache gehen,
in der Produktion wie in der administrativen Projekt-
abwicklung. So wird dank Fachwissen und technischer
Kapazität noch manche Tonne Papier in neuer Form
unsere Buchbinderei verlassen.
Wir setzen uns mit allem Engagement dafür ein.

Photographer: **Stephan Knecht**

Client: **BU BU**

Use: **Self-promotional shot**

Art directors: **R. Kuelling & Andy Schneiter**

Camera: **9x12 cm with 6x12cm roll film back**

Lens: **180mm**

Film: **120 Kodak Vericolor III**

Exposure: **f/32**

Lighting: **Electronic flash: 4 heads. 1 large soft box, 3 standard reflector heads.**

Props & set: **White seamless background**

Plan View

Side View

▼

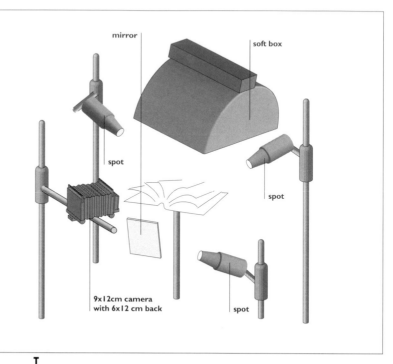

THIS LAYOUT CONSISTS OF A MAIN IMAGE, FIRST PRINTED ALL-IN AND THEN DISSECTED INTO FOUR PARTS, PLUS A ROLLED-UP VERSION OF THE SAME PRINT SHOT AGAINST A BLACK BACKGROUND. STEPHAN KNECHT MADE THE ENLARGEMENT HIMSELF, WITH ITS DELIBERATE BLUE CAST.

The book was fastened to a stand to create the impression that it was almost flying, or falling with its pages open. The key light is a spot above the book, to camera right: in particular, look at the shadows on the left-hand pages. This was supplemented by a further spot, above the book and to camera left, to help differentiate the pages on the right and to provide fill. A third light placed under the book is reflected by a small mirror which lightens the red-and-white sewing of the binding. Further fill is provided by spill from the background light, a 100x200cm soft box which is placed behind the book and above it.

Portions of the original colour print were then photographed individually, and the rolled-up print completes the image of a company well able to handle paper.

Photographer's comment:

The important thing is the open, fanned-out pages of the book, which was 20x30cm (8x12inches) closed.

Photographer: **Gérard de St. Maxent**

Client: *Le Grand Livre du Mois*

Use: **Press advertising**

Art director: **Stephane Mathieu**

Camera: **4x5 inch**

Lens: **210mm**

Film: **Fuji ISO 100**

Exposure: **1/60 second at f/16**

Lighting: **Electronic flash: 5 heads. 2 soft boxes used together, 1 large reflector with central diffuser, 2 spots.**

Props & set: **Props from various sources; painted background.**

Plan View

Side View

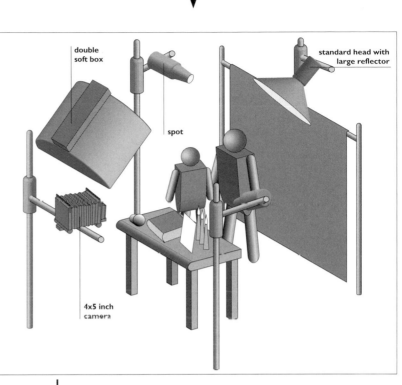

Like one or two other pictures in this book, Gérard de St Maxent's picture uses people as props; the "pack" itself (the book, *L'Enfant-Roi*) is very clearly the dominant part of the composition, with everything else subordinate to it and creating a setting for it.

The key light is a "bowl and spoon" above the centre of the set and slightly to the left: a large diffuse reflector with a central mask over the tube to avoid hot spots. Look at the shadows and highlights on the model's bosom. A spot, high and to the left, creates the streak of light on the background; another spot, very slightly in front of the subject and to camera right, lights the right-hand side of the picture including the book. Fill comes from two big soft lights, used side-by-side to create a bank 150cm square, directly above the camera.

Note how the area behind the candles and above the book has been allowed to go dark, emphasizing the flames of the candles, which in turn lead the eye down to the book.

Photographer's comment:

The intention was to create a Dutch ambiance.

▼

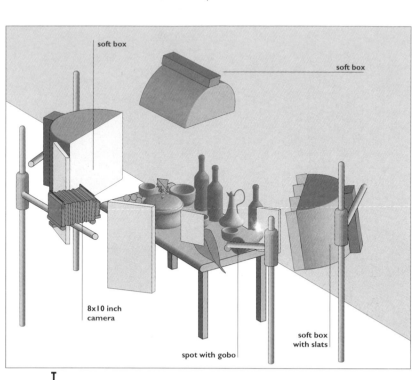

soft box

soft box

8x10 inch
camera

spot with gobo

soft box
with slats

Photographer: **Terry Ryan**

Assistant: **Neil Brunning**

Client: **Létang and Rémy**

Use: **Brochure for "The French Collection"**

Camera: **8x10 inch**

Lens: **360mm**

Film: **Kodak Ektachrome EPP ISO 100**

Exposure: **f/45**

Lighting: **Electronic flash: 4 heads**

Props & set: **Set built in house; props sourced by ourselves**

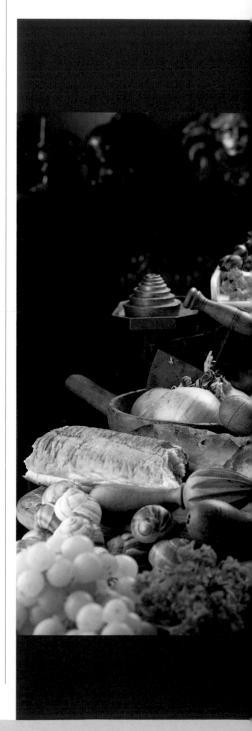

THE MAGNIFICENT COOKING-POT IN THE MIDDLE HAS CLEARLY NEVER BEEN USED; BUT THIS IS NOT IMPORTANT. WHAT IS IMPORTANT IS THE RANGE OF THINGS IT COULD BE USED FOR – AND BY ASSOCIATION, THE GOOD LIFE THAT IT IMPLIES.

The overall light comes from an SFF "super fish fryer" medium-to-large soft box over the subject and slightly to the rear (look at the shadows in front of things); this also provides the main highlight on the lid of the cooking vessel. Another SFF to camera left creates the effect of light streaming through a window, while a regular FF (fish frier – a small soft box) to camera right and behind the subject is fitted with baffles to increase the directionality of the light from it. This increases differentiation of vertical edges on the right. Finally, a 5000ws spot from well to camera right is fitted with a window mask to create the patterns on the background.

Two big white reflectors, each 120x240cm, are placed symmetrically to camera left and right to create still more even illumination.

Photographer's comment:

The main thing was to create a warm, inviting farmhouse mood.

Side View

Plan View

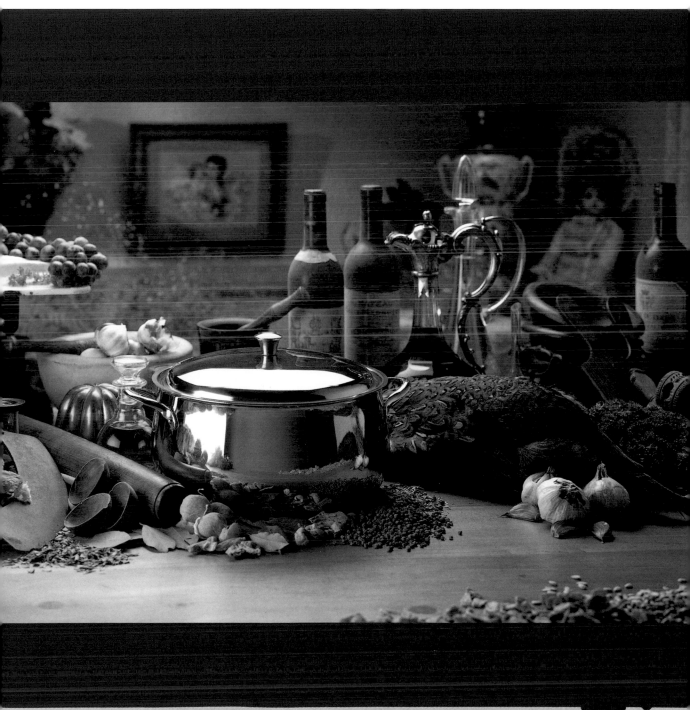

SPRAY CAN

▼

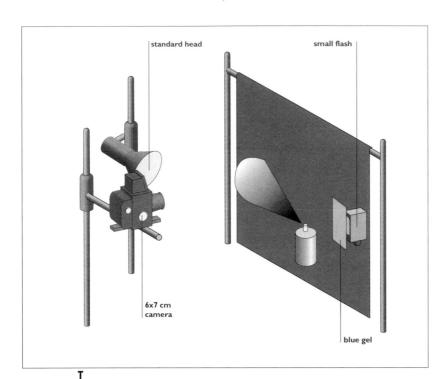

standard head

small flash

6x7 cm
camera

blue gel

Photographer: **Robert Stedman**

Client: **GAF**

Use: **Brochure**

Camera: **6x7 cm**

Lens: **180mm**

Film: **Fuji RDP ISO 100**

Exposure: **f/16**

Lighting: **Electronic flash: 1 main light, 1 small pocket unit to light spray.**

Props & set: **Black velvet background**

THE BASIC IDEA OF BACK LIGHTING A SPRAY TO SHOW IT UP AGAINST A DARK BACKGROUND IS FAIRLY OBVIOUS. LESS OBVIOUS IS USING A BLUE GEL TO MAKE IT LOOK REALLY DRAMATIC; AND LESS OBVIOUS STILL IS USING A SMALL FLASH UNIT TO GET A VERY FAST DISCHARGE TIME.

The point is that big studio flash units can have flash durations of as long as 1/300 second, or occasionally even longer, when what was needed was a very brief exposure to "freeze" the spray instead of photographing a diffuse cloud. Small high-voltage units can have flash duration times of 1/10,000 second or less, especially if they are switched to minimum power.

The background is black velvet, to make the spray stand out as clearly as possible. A small light head with a standard reflector is placed camera left, at about 45 degrees to the camera/subject axis, to provide the main light, and the pocket flash unit is close to the model's hand to provide dramatic rim lighting on the hand and to back light the spray. It has to be close, to get enough power even for an f/16 exposure.

Photographer's comment:

The client makes and tests aerosol products. We needed to show this basic theme. The can, which was filled with distilled water, was sprayed white to hide the logo.

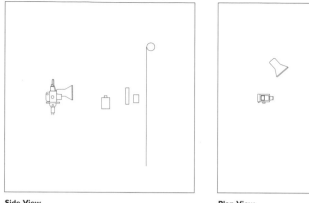

Side View

Plan View

Photographer: **Tan Wee Khiang**

Client: **Design Objectives**

Use: **Client's portfolio brochure**

Camera: **6x6 cm**

Lens: **150mm**

Film: **Agfa RS100 Professional**

Exposure: **30 seconds at f/16**

Lighting: **Electronic flash: 1 head. Large 1 metre reflector diffused through tracing paper; tungsten light brush used to emphasize shadows.**

Props & set: **Dark grey marble background**

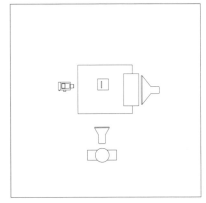

Plan View

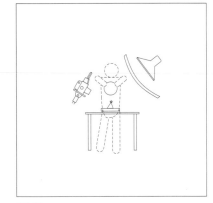

Side View

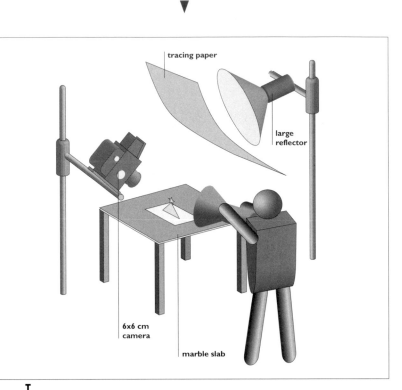

tracing paper

large reflector

6x6 cm camera

marble slab

ТHIS IS THE SORT OF SUBJECT WHICH COULD BE A DREAM OR A NIGHTMARE, DEPENDING ON YOUR ATTITUDE TO IT. IF YOU TRIED TO APPLY A STOCK LIGHTING SOLUTION, THE RESULT WOULD BE HORRIBLE WITH CONFUSING CROSSED SHADOWS. WITH AN ORIGINAL TREATMENT, IT IS HOWEVR A PORTFOLIO PIECE.

The main light is a big (100cm diameter) "Mola" light: a very large reflector with a central mask over the light source to prevent hot spots, while still creating a directional light. This back lights the set, provides a small amount of detail in the grey marble, and acts as a fill.

The true key, in the sense of providing the shadows, is the tungsten fibre optic light used to camera right as a back light to create the texture and shadows on the card itself. Used at a very glancing angle, this was panned to and fro for 30 seconds to diffuse the shadows slightly and create light and texture where it was wanted. The light brush allows the colours of the "pop up" to be emphasized, as well as the shape.

Photographer's comment:

Given a free hand with the whole idea, I chose to emphasize the design and the "pop up" look of the card.

SEASON'S GREETINGS

DESIGN OBJECTIVES

Photographer: **Mike Dmochowski**

Client: **Self-promotional shot**

Camera: **4x5 inch**

Lens: **210mm**

Film: **Kodak Ektachrome EPP**

Exposure: **Not recorded**

Lighting: **Tungsten: 2K focus spot**

Props & set: **Old printer's block.**

Plan View

Side View

▼

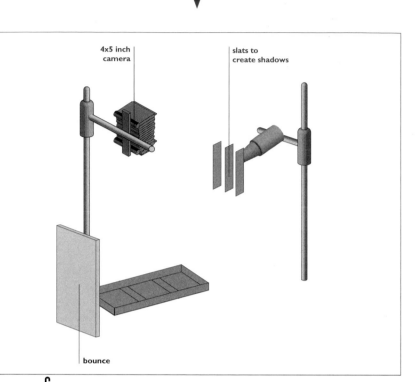

CREATING A MEMORABLE IMAGE OF THE COMPANY'S NAME IS NORMALLY SOMETHING WHICH IS LEFT TO THE TYPOGRAPHERS — BUT MIKE DMOCHOWSKI TURNED TYPOGRAPHER IN A UNIQUE WAY TO ADVERTISE HIS OWN BUSINESS, "STILLS IN THE STICKS". THE LIGHTING IS ALSO UNUSUAL.

He shot daylight-balance film under a tungsten spot, which was further filtered orange; the net result, as seen here, is an orange so rich and dark as to be virtually brown. The 2K focusing spot created a very hard, directional light which throws the type into harsh relief, and slats of cardboard between the light and the subject cast the straight shadows. By flopping the image, the name of the company can be made to read right-way-round; leaving it reversed is risky when it comes to the telephone number.

The overall effect is as if you had wandered into some long-abandoned warehouse, and found everything ready to use, just as it was left decades ago. This idea of happy discovery is germane to the image of Stills in the Sticks, which makes a point in its very name of not being based in central London.

Photographer: **Carl Warner**

Client: **Self-promotional work**

Camera: **8x10 inch**

Lens: **240mm**

Film: **Fuji Velvia**

Exposure: **f/64**

Lighting: **Electronic flash: 1 head**

Props & set: **Props lent by the garage down the road; rusty metal sheeting for background**

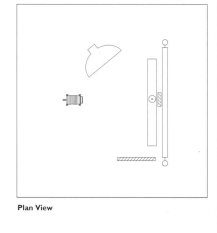

Plan View

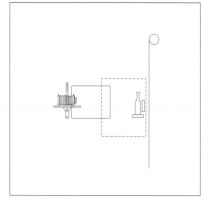

Side View

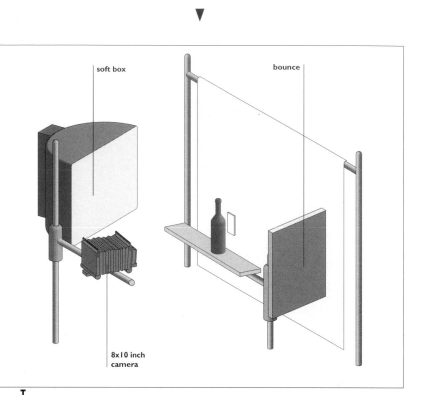

soft box

bounce

8x10 inch camera

THIS, THE LAST SHOT IN THE BOOK, DEMONSTRATES THE POWER OF A REALLY GOOD PHOTOGRAPH TO ENGAGE MORE SENSES THAN JUST SIGHT: IT SEEMS THAT ONE CAN ALMOST SMELL THE CHARACTERISTIC OILY-RAG SMELL OF AN OLD-FASHIONED GARAGE.

The actual lighting is however very simple. A medium-sized soft box to camera left is the sole light source. It creates clear, hard-edge reflections on the bottle, and picks out characteristic details in the rest of the picture: the porcelain of the sparking plug, the texture of the rag, the form of the oil-can spout and handle. A reflector to camera right provides some fill, and helps to differentiate the right-hand edges of the bottle and the cans from the background, while a small silver reflector behind the bottle kicks light back through the oil to separate it still more from the background; without that reflector, it would merge too much into the shadows. The composition and the choice of props, together with the simple but well-executed lighting, make a still life which can compete with any painting.

Photographer's comment:

This captures the essence of the product in a way that projects its quality and reflects its long-standing history.

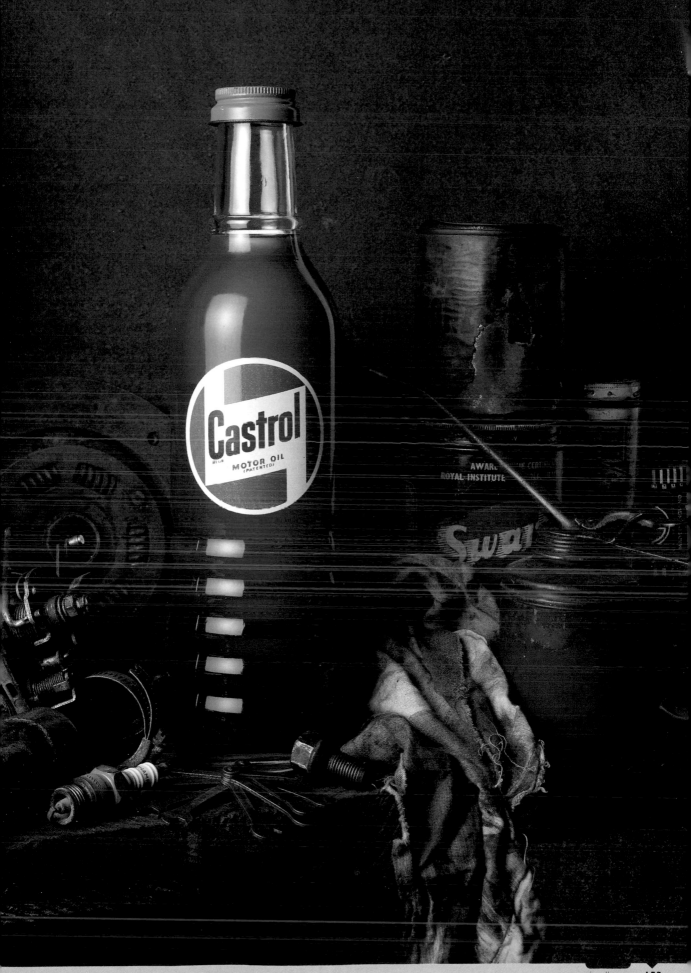

8
directory of photographers

Photographer: **NISHIDE ATSUO**
Firm: J.I.B. CO
Nationality: JAPANESE
Address: 7–4–7 HIGASHI-NAKAHAMA
JOTO-KU, OSAKA
JAPAN
Telephone: + 81 (6) 968 5454
Fax: + 81 (6) 963 3172
Biography: *Graduate of Osaka Professional Photography School. Specializes in commercial photography. Private exhibition in Gallery View in Osaka, 1994.*
Product shot: Discman p132/133

Photographer: **MARIO CANDELAREZI**
Nationality: ARGENTINE
Address: SAN MARTIN 969 6° PISO
ARGENTINA
Telephone: + 54 444 8109
Biography: *Independent product photographer with 14 years' experience in media publicity.*
Product shot: Cave Louis Joullien p32/33

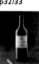

Photographer: **JAMES DiVITALE**
Firm: DiVITALE PHOTOGRAPHY
Nationality: AMERICAN
Address: 420 ARMOUR CIRCLE NE
ATLANTA
GA 30324
USA
Telephone: + 1 (404) 892 7973
Fax: + 1 (404) 938 1394
Biography: *A commercial photographer in Atlanta for sixteen years. Nine years ago, he established his own studio together with his wife Sandy, who acts as the studio's production coordinator. Jim's work has been recognized in annuals such as Advertising Photographers of America's Creative Awards (One and Two); Graphis Photo 93 and 94; and Professional Photographers of America's Loan Collection 1990, 1992, 1993 and 1994. He has published his work in the Creative Black Book 1992–1995, Workbook 1995, Single Image Workbook #15–18, Klik!/Showcase Photography #2–4, and the Art Directors' Index 1995.*
Product shot: Heartland Harvest p58/60

Photographer: **MIKE DMOCHOWSKI**
Firm: STILLS IN THE STICKS
Nationality: BRITISH
Address: PHOENIX, FLAUNDEN LANE
FELDON
HERTS HP3 0PA
ENGLAND
Telephone: + 44 (1 831) 321 202,
(1 442) 832 526, (1 923) 211 077

Fax: + 44 (1 923) 228 702
Product shots: Fan p110/111, Stills in the Sticks p150/151

Photographer: **FRANCO DONAGIO**
Nationality: ITALIAN
Address: VIA POLA N° 6 C.A.P.
20124 MILANO
ITALY
Telephone/Fax: + 39 (2) 60 36 28
Biography: *Franco Donagio has been an advertising photographer in Milan since 1979. He works with agencies and direct with clients, who typically allow him a free hand to interpret the subject. Clients have included St. Paul de Vence in France (fashion), Amnesty International in Italy, SICOF (photography fair), Accademia Carrara di Bergamo. He has been profiled in Progresso Fotografico, Z))M, and Living in Milan. He is heavily involved in the photographic side of the Milan Fair.*
Product shots: Dior p76/77, Chopard p82/83

Photographer: **JOSÉ ANTONIO EGEA RICO**
Nationality: SPANISH
Address: RONDA SAN PEDRO 32, 1o D.
08010 BARCELONA
SPAIN
Telephone: + 34 (3) 19 61 67
Fax: + 34 (3) 17 64 49
Biography: *Studied photography in Paris and Barcelona. Worked in the weekly press, specializing in sport (particularly golf), fashion and editorial photography. Since 1987 he has specialized increasingly in jewellery, watches and clocks.*
Product shot: Pearl Earring p38/39

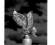

Photographer: **LOOI WING FAI**
Nationality: MALAYSIAN
Address: NO. 4 LORONG DATUK SULEIMAN SATU
TAMAN TUN. DR. ISMAIL
60 000 KUALA LUMPUR
MALAYSIA
Telephone: + 60 (3) 71 95 181 AND
+ 60 (3) 71 95 479
Fax: + 60 (3) 71 79 616
Biography: *Always judges himself by what he feels capable of doing – and no matter what the challenge, he always wants to meet it. Loves to experiment with equipment on the cutting edge of technology.*
Product shot: Technics p120/121

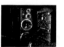

Photographer: **MANUEL FERNANDEZ VILAR**
Nationality: SPANISH
Address: AVDA. CONSTITUCION—20
26001 LOGROÑO (LA RIOJA)
SPAIN
Telephone: + 34 (41) 23 19 39
Biography: *Professional photographer for the last 35 years. Various exhibitions; winner of the Goya prize for the best industrial photograph in 1991.*
Product shots: Zapato Rojo p42/43, Pendant p88/89

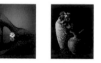

Photographer: **MIKE GALLETLY**
Nationality: BRITISH
Address: STUDIO 3, THE PEOPLE'S HALL
OLAF STREET
LONDON W11 4BE
ENGLAND
Telephone: + 44 (1 71) 221 0925
Fax: + 44 (1 71) 229 1136
Biography: *Has been working as a still life advertising photographer since 1976. Based in West London, he produces original photography for advertising, brochures and books throughout Europe. He works both directly for clients and through advertising agencies and design groups, with subjects as diverse as cars and cosmetics.*
Product shot: Avon p86/87

Photographer: **ROY GENGGAM**
Nationality: INDONESIAN
Address: JL KH MUHASYIM VIII NO. 37
CILANDAH-JAKARTA
INDONESIA
Telephone: + 62 (21) 76 93 697
Biography: *Photographer with cinematography education, specializing in advertizing and architectural photography.*
Product shot: BCA Credit Cards p96/97

Photographer: **J. M. GODEFROID**
Nationality: BELGIAN
Address: 34–36 CHAUSSÉE DE TUBIZE
B–1440 WAUTHIER-BRAINE
BELGIUM
Telephone: + 32 (2) 366 2356
Fax: + 32 (2) 366 2046
Biography: *Since 1983, has worked as an independent advertising and industrial photographer. His studio is in Braine on the outskirts of Brussels, and consists of 300 square metres on three levels, with digital imaging facilities.*
Product shot: Vin et Nature p101/103

Photographer: **ARTLI ALI HAWIJONO**
Nationality: INDONESIAN
Address: PALEM TIMUR C–72
JAKARTA 11510
INDONESIA
Telephone: + 62 (21) 565 3528
Fax/Phone: + 62 (21) 566 9050
Biography: *Having graduated from the Academy of Art College San Francisco, with a degree in Graphic Design, he started his career in 1987 as the creative art director and also photographer for a leading multinational tableware manufacturer in Indonesia. In 1991 he decided to set up a studio which concentrated on still life, industrial and corporate photography.*
Product shots: JJ Jeans p44/45, Case p48/49, Calendar p136/137

Photographer: **ALLAN HEWETT**
Firm: ALLAN HEWETT ASSOCIATES
Nationality: ENGLISH
Address: 10 WOOD STREET, CALNE
WILTS SN11 0DA
ENGLAND
Telephone: + 44 (1 249) 816 405
Biography: *He started his photographic career in the early '60s, apprenticed to a London firm of industrial photographers where (in the darkroom) he learned to appreciate the importance of good lighting technique. Approximately 30 per cent of the work generated by UK agencies is exported into Europe, the Middle East and recently Russia. Clients include Bristol Myers, Peter Cook International, Crosse and Blackwell, Counstan, DEP (UK), Epson, Heinz, Myer Dunmore, Schwarzkopf, Sterling Health, Systema, Wellcom, Virgin and Wilkinson Sword.*
Product shots: Corimist p104/105, Valves p128/129

Photographer: **ROGER HICKS**
Nationality: BRITISH
Address: 5 ALFRED ROAD
BIRCHINGTON
KENT CT7 9ND
ENGLAND
Telephone: + 44 (1 843) 848 664
Fax: + 44 (1 843) 848 665
Biography: *Started photography as a hobby in Bermuda at the age of 16; first worked professionally (as an assistant) in London in 1973. Has illustrated many books of his own, including several cookbooks, books on photography, and travel books, as well as providing pictures to accompany other people's words. Also works as editor and magazine journalist. Currently based in UK but lived in California 1987–1992.*

Since 1982 has been married to fellow-photographer and writer Frances E. Schultz.
Product shot: Lenses p130/131

Photographer: **COSKUN IPEK**
Nationality: TURKISH
Address: FULYA CAD. 29/3–41
80290 ISTANBUL
TURKEY
Telephone: + 90 (212) 21 14 497
Fax: + 90 (212) 21 21 393
Biography: *Born in Istanbul in 1965, he graduated from the Department of Photography in the Faculty of Arts at the Istanbul Mimar State University in 1988. After eighteen months' experience at one of the most important Turkish advertising agencies, he established his own studio with two partners in 1992; he specializes in food, still life, fashion, interior and architectural photography.*
Product shot: Heart p40/41

Photographer: **TAN WEE KHIANG**
Nationality: SINGAPOREAN
Address 1: 275 THOMSON RD. #02–03
NOVENA VILLE
SINGAPORE 1130
Telephone: + 65 254 7677
Fax: + 65 254 7000
Biography: *Began photography as a hobby in the early 70s. After starting in editorial photography he moved into commercial photography. After a couple of years he was invited to join three Japanese photographers in Tokyo. He has now had his own photography business for 6½ years. Local and international clients include AT&T, Apple, Nixdorf Computer, Epson, Glaxo, Brown & Root, British American Tobacco, C. Melchers, GEC, Texas, Hewlett Packard, SIA, Malaysian Airlines.*
Product shot: Greetings Card p148/149

Photographer: **STEPHAN KNECHT**
Nationality: SWISS
Address: SPINNEREISTR. 10
8135 LANGNAU–ZURICH
SWITZERLAND
Telephone: + 41 (1) 713 20 13
Fax: + 41 (1) 713 10 00
Biography: *Experienced in processing, monochrome, E–6 and print, as well as being a photographer.*
Product shot: Book p138/140

Photographer: **JONATHAN KNOWLES**
Nationality: BRITISH
Address: 48A CHANCELLORS ROAD
LONDON W6 9RS
ENGLAND
Telephone: + 44 (1 81) 741 7577
Fax: + 44 (1 81) 748 9927
Biography: *Specialist in still life and special effects.*
Product shots: George Dickel p18/19, Stella Dry (Blue) p28/29

Photographer: **PETER LAQUA**
Nationality: GERMAN
Address: MARBACHERSTR. 29
78048 VILLINGEN
GERMANY
Telephone: + 49 (7721) 30501
Fax: + 49 (7721) 30355
Biography: *Born in 1960, Peter Laqua studied portraiture and industrial photography for three years. Since 1990 he has had his own studio, specializing in industrial clients. A prizewinner in the 1994 Minolta Art Project, he has also had exhibitions on the theme of "Pol-Art" (fine art photography with Polaroid materials) in 1994 and on the theme of "Zwieback" in Stuttgart in 1992.*
Product shot: Shower Gel p80/81

Photographer: **MATTHEW LEIGHTON**
Nationality: BRITISH
Address: CALLE 61 #17–37
BOGOTA
COLUMBIA
Telephone: + 57 (1) 249 3771 AND
+ 57 (1) 249 0275
Fax: + 57 (1) 218 9648
Biography: *He worked in different studios in London for five years and moved to Columbia in 1981. He now has his own advertising studio and laboratory in Bogota and specializes in food, still life, fashion and special effects for agencies and direct clients such as General Foods, JCB, Johnson & Johnson, Kellogs, Mastercard, Nabisco, Pepsi Cola, Plumrose, Proctor and Gamble, Unilever, and many local companies. He has also produced photographs for a series of 15 cookery books. He won five awards in 1993 for "best photographer for the Andean countries" and the Golden Condor with Leo Burnett.*
Product shot: Rechargeable Torch p126/127

Photographer: **JAIME MALÉ**
Nationality: SPANISH
Address: C/SIBELIUS, 5 LOCAL 1
BARCELONA
SPAIN

Telephone: + 34 (3) 447 0470
Fax: + 34 (3) 447 0217
Biography: *Sixteen years of experience in advertising photography, specializing in still lifes. Has worked for most of the main agencies and graphic studios, and has shot many leading brands.*
Product shot: Café p66/67

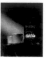

Photographer: **ALBERT MARLI RASOS**
Nationality: SPANISH
Address: C ARIBAU, 252–3è 1A
08006 BARCELONA
SPAIN
Telephone: + 34 (3) 200 81 81
Fax: + 34 (3) 202 35 76
Biography: *Started work in Barcelona in the late 1950s. With his considerable experience, he has formed a strong personal vision in all areas of commercial photography, as is confirmed by a client list which includes numerous prestige advertising agencies. In 1982 he opened his own studio, from which he has worked both for agencies and directly for clients.*
Product shot: Pan Artesano p64/65

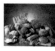

Photographer: **RICHARD PAINTER**
Nationality: BRITISH
Address: 39 STAFFORDSHIRE STREET
LONDON SE15 5TL
ENGLAND
Telephone/Fax: + 44 (1 71) 277 6029
Biography: *Became freelance by accident shortly after leaving Leicester College of Art. Has worked on accounts such as BT, Giroflex Seating, BP, Gordon Russell Furniture, Concord Lighting, Rank Xerox, Black and Decker, Royal Mail, Ever Ready and Philips Lighting. He specializes in producing "creative" photographs of technical or problem products.*
Product shot: Lights p114/116

Photographer: **SALVIO PARISI**
Nationality: ITALIAN
Address: VIA XX SETTEMBRE 127
20099 SESTO S.G.
MILANO
ITALY
Telephone: + 39 (2) 22 47 25 59
+ 39 (2) 26 22 55 67
Fax: + 39 (2) 71 44 30
Biography: *The essentially commercial nature of his photography works things in such a way that people, models and objects become a purely physical support for the basic advertising idea or product. "Accessories" such as charm, styling, femininity and appeal are only*

apparently left out. That's how a "beautiful" face becomes the best basis for make-up; a sculptured leg, a way of showing off a shoe; and a detail of a body a complement to a perfume.
Product shots: Drakkar Noir p78/79, Girl and Perfume p84/85

Photographer: **EDWIN RAHARDJO**
Nationality: INDONESIAN
Address: JI. KEMANG RAYA No. 21
KEMANG, JAKARTA 12730
INDONESIA
Telephone: + 62 799 0278 AND + 62 799 8049
Fax: + 62 799 0278
Biography: *Educated in the U.S. with architectural and interior design background. Started professional career as photographer in 1980. He has worked for more than 800 clients such as De Beers Diamond, Toyota, Panasonic, Mitsubishi, Mercantile Club, etc. Besides a photo studio, he also owns a fine art gallery and hobby shop.*
Product shot: Camping p108/109

Photographer: **MASSIMO ROBECCHI**
Firm: CAFÉ ESTUDIOS
Nationality: ITALIAN
Address: CAFÉ ESTUDIOS
VIA GIOVANNI DA CERMENATE 23
22063 CANTÙ (COMO)
ITALY
Telephone/Fax: + 39 (31) 71 66 82
Biography: *Born in Milan in 1960, he started working as an assistant at a major studio in 1980, and now works equally happily in still life, fashion and beauty for editorial use and advertising campaigns. Important clients include Backer Spielvogel Bates, Chivas Regal, Fiat, Kim Top Line, Levis, Proctor & Gamble, Warner Bros and others. He is interested in working with agents outside Italy.*
Product shot: Bottle p20/21

Photographer: **FABRIZIA DI ROVASENDA**
Nationality: ITALIAN
Address: FASE S.A.S. DI FABRIZIA DI ROVASENDA
VIA SACCHI 26
TORINO 10128
ITALY
Telephone: + 39 (11) 56 25 287
Fax: + 39 (11) 56 22 829
Biography: *Diploma from the Liceo Artistico di Milano in 1969. Worked at the Kodak laboratory in Turin until the end of 1972, followed by several years' experience as an assistant in Milan and Turin on a wide range of subjects*

including architectural interiors and car photography (Fiat). Since 1978 he has had his own studio specializing mainly in still life.
Product shot: Gancia dei Gancia p30/31

Photographer: **TERRY RYAN**
Firm: TERRY RYAN PHOTOGRAPHY
Nationality: BRITISH
Address: 193 CHARLES STREET
LEICESTER LE1 1LA
ENGLAND
Telephone: + 44 (1 16) 254 46 61
Fax: + 44 (1 16) 247 09 33
Biography: *Terry Ryan is one of those photographers whose work is constantly seen by a discerning public without receiving the credit it deserves. Terry's clients include The Boots Company Ltd., British Midlands Airways, Britvic, Grattans, Pedigree Petfoods, The Regent Belt Company, Volkswagen and Weetabix to name but a few. The dominating factors in his work are an imaginative and original approach. His style has no bounds and he can turn his hand equally to indoor and outdoor settings. He is meticulous in composition, differential focus and precise cropping, but equally, he uses space generously where the layout permits a pictorial composition. His work shows the cohesion one would expect from a versatile artist.*
Product shots: Shapers Range p56/57, The French Collection p144/145

Photographer: **GÉRARD DE SAINT MAXENT**
Nationality: FRENCH
Address: 14 BD EXELMANS
75016 PARIS
FRANCE
Telephone: + 33 (1) 42 24 43 33
Biography: *Has worked in advertising and publicity since 1970. Specializes in black & white.*
Product shot: L'Enfant Roi p141/143

Photographer: **ENRIQUE SEGARRA ALBERU**
Nationality: MEXICAN
Address: MURILLO 17–4
COL. NONOALCO–MIXCOAC
MEXICO, D.F. 03910
Telephone: + 52 (5) 563 35 60
Fax: + 52 (5) 611 36 91
Biography: *He has been involved in photography from a very early age, and has his own studios in Mexico, D.F. with some of the most advanced equipment in the country, including Kodak Premier retouching and image manipulation*

facilities. He has attended numerous courses: Dean Collins, Ken Marcos, Peter Gowland, and several from Kodak, including computer imaging courses in Rochester and Maine. He has also taught courses at the Universidad de la Comunicación and the Club Fotogràfico de México as well as speaking at conferences and colloquia at such institutions as the Câmera Nacional de la Industria de la Transformaciòn and the Universidad Autónoma de México. Clients include Avon Cosmetics, Black & Decker, Johnson & Johnson, Bacardi y Cià, Cosmar, Consupharma, Gillette, Nestlé, Domecq, Coca-Cola, Kellogs, Mennen, Proctor & Gamble, Delmonte, Princess Cruises, Levi Strauss and many other national and international names.
Product shot: Deodorant p90/91

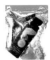

Photographer: **ROBERT STEDMAN**
Nationality: AMERICAN (RESIDENT IN SINGAPORE)
Address: BLOCK 28
KALLANG PLACE #03–16/17
SINGAPORE 1233
Telephone: + 65 294 4101
Fax: + 65 294 0515
Biography: *Robert Stedman originally hails from Los Angeles, California. After graduating university he decided to seek adventure in the South Seas and signed aboard as first mate on a trading schooner. He finally ended up in South East Asia where he worked for many years as a freelance photojournalist — travelling extensively in Asia, China, Central Europe, Africa and the U.S. In 1988, he established a photography and graphic design studio in Singapore which serves local and multinational companies.*
Product shots: Gin Sling p24/25, Shoes p46/47, Metal Bags p50/51, Reptile Bags p52/53, Miligrid Connectors p117/119, 2.0 Pitch Connectors p124/125, Spray Can p146/147

Photographer: **PAULINE MARY STEVENS**
Nationality: MEXICAN
Address: PICACHO 351
PEDREGAL DE SAN ANGEL
MEXICO, DF 01900
Telephone: + 52 (5) 652 1625
Fax: + 52 (5) 568 9788
Biography: *Studied photography in Atlanta, Georgia at the Portfolio Center 1988–1990. Worked as an assistant in New York (six months) and Mexico (two months). For the last three years she has been a freelance, working for advertising agencies, design studios and directly for clients, and she has attended workshops given by Deborah Turberville, Nancy Brown and Arnold Newman.*
Product shots: Skin Perfecting Cream p74/75, Royal Dutch Cigars p106/107

Photographer: **RAYMOND TAN**
Nationality: SINGAPOREAN
Address: 4 LENG KEE ROAD
THYE HONG CENTRE
SINGAPORE 0315
Telephone: + 65 479 41 73
Fax: + 65 479 47 64
Biography: *He started from scratch as an assistant. It's been seven or eight years now, and he prefers shooting products to fashion. He strongly believes that photography is a never-ending process of learning; nobody can ever truly say that he is an expert and has nothing more to learn.*
Product shots: Dunhill Whisky p22/23, Hard Labour p122/123

Photographer: **TERRY TSUI**
Nationality: BRITISH
Address: 2/F, C, 364–366 HENNESSY ROAD
WANCHAI
HONG KONG
Telephone: + 852 574 1809
Fax: + 852 572 2126
Biography: *A professional photographer and photography lecturer in Hong Kong. He has over ten years' experience in commercial and advertising photography, specializing in still life, jewellery, architecture and interiors; clients have included numerous major corporations.*
Product shots: Emeralds p36/37, Gitanes p70/71, Vintage-style Watch p94/95

Photographer: **CARL WARNER**
Nationality: BRITISH
Address: 25 MALVERN MEWS
LONDON NW6 5PT
ENGLAND
Telephone: + 44 (1 71) 328 6534
Fax: + 44 (1 71) 625 0221
Biography: *Works mainly in advertising and design, shooting on all formats both in and out of the studio.*
Product shot: Castrol p152/153

Photographer: **ANDREW WHITTUCK**
Nationality: BRITISH
Address: UNIT 3, 21 WREN STR.
LONDON WC1X 0HF
ENGLAND
Telephone: + 44 (1 71) 278 0691
Fax: + 44 (1 71) 837 1934
Biography: *Born in London and studied at the London College of Printing. He specializes in food and still life photography and has worked for a wide range of advertising agencies, design groups and commercial clients in Europe.*
Product shots: Perrier p68/69, Penhaligon (Blue) p98/101

Photographer: **MARK WRAGG**
Nationality: BRITISH
Address: GATE STUDIOS, WALKERS PLACE
LACY ROAD
LONDON SW15 1PP
ENGLAND
Telephone: + 44 (1 81) 780 11 86
Fax: + 44 (1 81) 789 01 40
Product shot: Soft Drinks p61/63

Photographer: **STEFANO ZAPPALÀ**
Firm: GREEN & EVERGREEN S.A.S.
Nationality: ITALIAN
Address: VIA CARLO MADERNO 2
20136 MILANO
ITALY
Telephone: + 39 (2) 58 10 69 50
Fax: + 39 (2) 58 11 43 88
Biography: *A commercial still life and food photographer based in Milan. He specializes in complex lighting situations and painterly sets. Clients include Motta, Barilla, Firestone and Fratelli Rossetti.*
Product shot: Campari p26/27

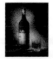

Acknowledgements

First and foremost, we must thank all the photographers who gave so generously of pictures, information and time. We hope we have stayed faithful to your intentions, and we hope you like the book, despite the inevitable errors which will have crept in. It would be invidious to single out individuals, but it is an intriguing footnote that the best photographers were often the most relaxed, helpful and indeed enthusiastic about the Pro Lighting series.

We must also thank Christopher Bouladon and his colleagues in Switzerland, and of course Brian Morris who invented the whole idea for the series; and in Britain, we owe a particular debt to Colin Glanfield, who was the proverbial "ever present help in time of trouble."

The manufacturers and distributors who made equipment available for the lighting pictures at the beginning of the book deserve our thanks too: Photon Beard, Strobex and Linhof and Professional Sales (UK importers of Hensel flash). And finally, we would like to thank Chris Summers, whose willingness to make reference prints at odd hours made it much easier for us to keep track of the large numbers of pictures which inevitably crossed our desks.